DIY Art Projects for the Un-Artist

How to Create 10 Beautiful DIY Art Projects from Recycled Objects

Step-by-Step Photographs and Easy to Follow Instructions

By

Sara Kandel

Copyright © 2019 – **Lost River Publishing House**

Email: Publisher@LostRiver.pub

All Rights Reserved.

No part of this publication may be reproduced, stored in a retrieval system or transmitted in any form or by any means, electronic, mechanical, photocopying, recording or otherwise without the proper written consent of the copyright holder, except as permitted under Sections 107 & 108 of the 1976 United States Copyright Act, without the prior written permission of the publisher.

Lost River Publishing House publishes its books and guides in a variety of electronic and print formats, Some content that appears in print may not be available in electronic format, and vice versa.

Cover design

Mary Perez

First Edition

Contents

Special Thanks ... 1

Introduction ... 2

Bottle Bottom Tree Painting ... 3

 Supplies ... 4

 Preparation ... 5

 Steps .. 5

 Step 1: Paint a Fade ... 6

 Step 2: Sketch a Tree ... 7

 Step 3: Painting the Tree ... 15

 Step 4: Prepare to Stamp .. 16

 Step 5: Leaf Prints .. 17

 Step 6: Dry Time ... 18

Decorative Beans .. 20

 Supplies ... 21

 Preparation ... 21

 Steps .. 21

 Strep One: Scattering the Beans ... 22

 Step 2: Spraying the Beans ... 22

 Step 3: Dry and Spray Again .. 23

 Step 4: Spray the Underside ... 23

 Step 5: Dry and Sort .. 24

 Step 6: Repaint as Needed .. 25

- Step 7: Place them in a Vessel .. 26

Record Bowl .. 28

Supplies .. 28

Preparation .. 29

Steps .. 29

- Step 1: Heat a Large Pot of Water .. 29
- Step 2: Warming the Vinyl ... 30
- Step 3: First Pinch .. 31
- Step 4: Rotate, Warm, and Pinch ... 32
- Step 5: Rotate, Warm, and Pinch Again 33
- Step 6: Repeat ... 33
- Step 7: Touch-ups ... 34
- Step 8: Final Inspection ... 35

Can Candle ... 37

Supplies .. 37

Preparation .. 38

Steps .. 39

- Step 1: Decide and Dot ... 39
- Step 2: Drill the Holes .. 40
- Step 3: Inspect and Touch-Up .. 41
- Step 4: Paint ... 41
- Step 5: Second Coat .. 43
- Step 6: Touch-Ups ... 43

 Step 7: Top Coat .. 43

 Step 8: Final Inspection ... 44

Text Silhouette Art ... 45

 Supplies .. 45

 Preparation ... 46

 Steps .. 47

 Step 1: Make a Text Filled Background ... 47

 Step 2: Prep Your Outline ... 48

 Step 3: Trace .. 50

 Step 4: Cut ... 51

 Step 5: Attach the Silhouette to the Mat ... 51

 Step 6: Prep the Accents ... 52

 Step 7: Glue Thread to the Accent Shapes 53

 Step 8: Attach Thread to the Mat .. 54

 Step 9: Put the Mat in the Frame .. 56

Melted Crayon Art ... 57

 Supplies .. 57

 Preparation ... 59

 Steps .. 59

 Step 1: Picking the Crayons ... 59

 Step 2: Remove the Wrappers .. 60

 Step 3: Prepping the Canvas .. 60

 Step 4: Attach Crayons ... 62

Step 5: Determine the Angle of the Canvas ... 63

Step 6: Melt the Crayons with a Blow Dryer ... 64

Step 7: Melt the Crayons with a Lighter .. 65

Step 8: Allow to Dry ... 67

Step 9: Remove the Bowl or Plate .. 68

Step 10: Prep the Silhouette ... 69

Step 11: Trace the Silhouette .. 69

Step 12: Outline the Silhouette .. 70

Step 13: Paint the Silhouette .. 70

Colorful Wax Painting .. 72

Supplies .. 73

Preparation ... 73

Steps ... 74

Step 1: Peel Crayon Wrappers .. 74

Step 2: Break and Sort Crayons ... 74

Step 3: Melt the Crayons ... 75

Step 4: Remove and Stir .. 75

Step 5: Paint .. 76

Button Tree Painting ... 78

Supplies .. 78

Preparation ... 79

Steps ... 79

Step 1: Sorting and Cleaning Buttons ... 80

Step 2: Sand and Rinse the Buttons ... 80

Step 3: Spray Paint Buttons .. 81

Step 4: Painting the Background .. 82

Step 5: Top and Second Coats .. 83

Step 6: Sketch Your Tree .. 84

Step 7: Paint the Tree .. 85

Step 8: Gather Buttons and Do Touch-ups 86

Step 9: Organize the Buttons on the Tree 87

Step 10: Glue the Buttons .. 88

Nail Yarn Art .. 90

Supplies .. 90

Preparation .. 91

Steps .. 92

Step 1: Cut Wood ... 92

Step 2: Sand the Wood .. 93

Step 3: Apply Polyurethane or Stain .. 94

Step 4: Sand the Wood Again .. 95

Step 5: Apply a Second Coat ... 95

Step 6: Lightly Sand ... 96

Step 7: Mark the Wood for the Nail Placement 96

Step 8: Hammer the nails .. 98

Step 9: Review Nail Placement; Prep the Yarn 99

Step 10: Tie Embroidery Yarn on First Nail 101

Step 11: Outline the Object ... 101

Step 12: Weave Yarn Across the Nails 102

Step 13: Repeat Steps 10-12 ... 103

Wood Photo Transfer ... 104

Supplies ... 105

Preparation ... 105

Steps ... 106

Step 1: Obtain Laser-Printed Copies 106

Step 2: Cut the Photo Copy ... 107

Step 3: Cut the Wood ... 107

Step 4: Sand the Wood ... 108

Step 5: Apply Photo Transfer Gel ... 109

Step 6: Place the Photo Copy .. 110

Step 7: Use a Wet Rag .. 112

Step 8: Wet Blanket .. 113

Step 9: Rub ... 113

Step 10: Peel .. 114

Step 11: Allow the Wood to Dry .. 115

Step 12: Round 2 Rub .. 116

Step 13: Round 3 Rub .. 117

Step 14: Spot Rob ... 118

Step 15: Apply a Top Coat ... 119

Step 16: Buff .. 120

Step 17: Second Coat ... 121

Step 18: Light Buff .. 121

Step 19: Enjoy! ... 122

Conclusion ... 123

Special Thanks

I would like to dedicate this book to my mother. I appreciate her love for creating eclectic art pieces. When I was a child, I was always surrounded by paint, clay, and beautiful art made from reused and recycled items.

I was never afraid of making messes. My mother was always very patient with me. I can never recall a time when I wasn't immersed in colorful art. She was never concerned with doing things "right" with art as long as it expressed what was in your heart.

Creating art helped me through some darker times in my life. It helped me get through those difficult teenage years. It enabled me to adjust to life outside of my childhood home when I became an adult.

I hope that this short introduction to these 10 easy art projects will spark a love for making beautiful things in you, too. My wish is that you can find an outlet for exhibiting what's in your heart.

Mom, this book is for you.

Introduction

Life is full of colors!

Ralph Waldo Emerson once said, "Every artist was first an amateur." No statement about art was ever truer.

Taking the first step is sometimes the hardest, especially If you don't consider yourself to be particularly artistic.

I assure you, even you can create beautifully crafted art pieces! In this book, I show you how to complete 10 simple do-it-yourself art projects with easy to follow, step-by-step instructions.

Do you have some old crayons lying around? Two of the projects in this book will show you how to use those to make lovely conversation pieces. Do you have some old scrap wood from that home renovation? Two projects will show you how to turn that scrap wood into awesome works of art.

These projects utilize stuff you probably already have laying around the house. Creating art doesn't have to be expensive at all.

What are we waiting for? Let's get crafting!

Bottle Bottom Tree Painting

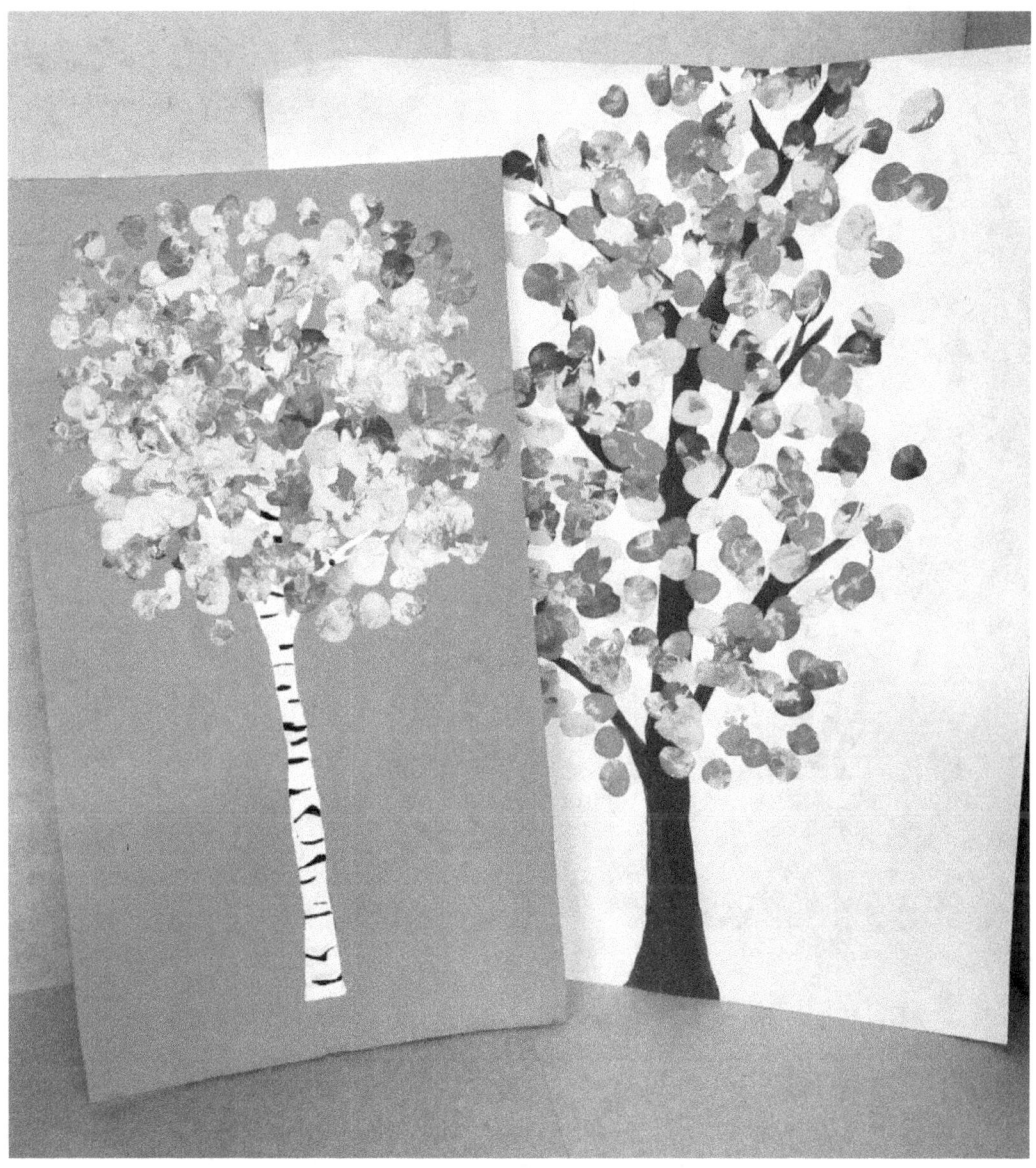

Skill Level: Easy

This is an easy painting, fun for adults and children alike. Children age nine and younger may require adult supervision.

Supplies

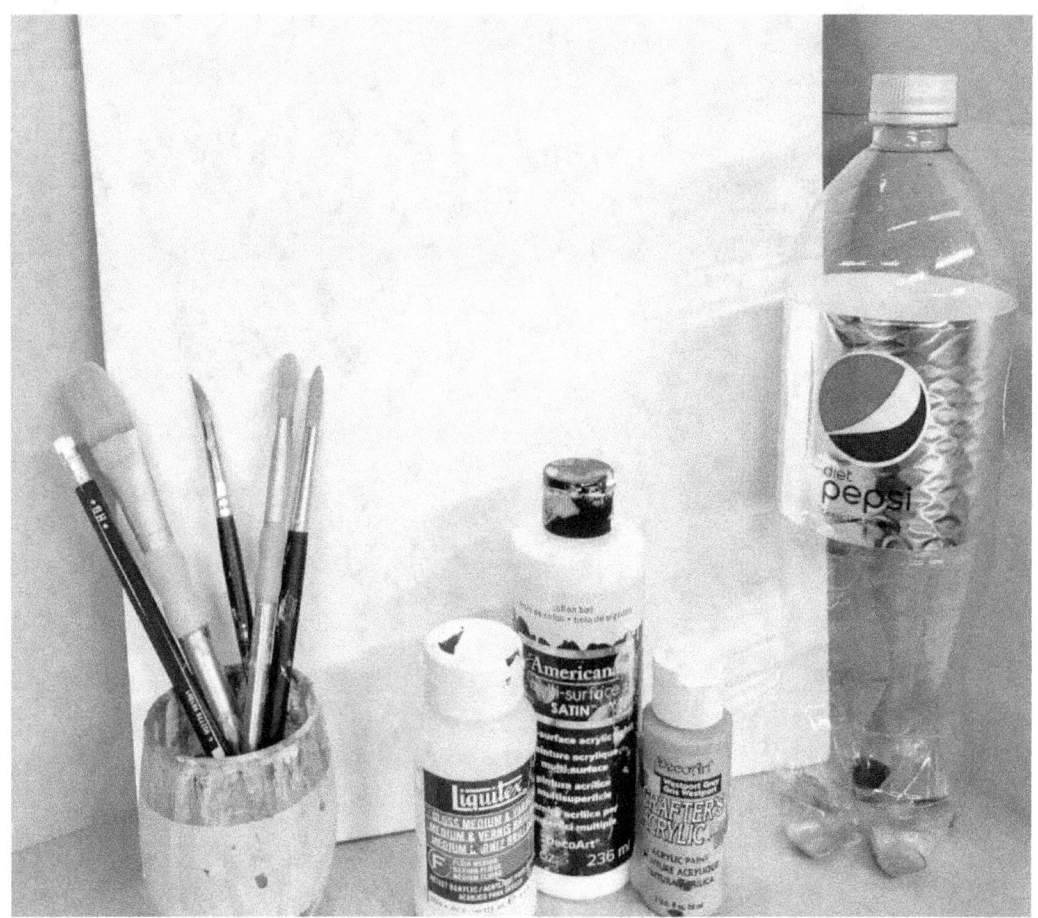

- Rectangular Canvas or Canvas Paper (size 11-by-14 inches or larger recommended)

- Pencil

- Paint Brush(es)

- Paper Plate or Palate (for paint)
- Brown or Black Craft or Tempera Paint (for tree trunk)
- Empty 20-ounce Soda Bottle (or one-liter or two-liter bottle)
- Color-of-Choice Craft or Tempera Paint (for leaves/flower buds)
- Color-of-Choice Craft or Tempera Paint (for background)
- Tree-trunk stencil or print-out of tree silhouette

Preparation

Prior to creating your artwork, set-up a work area with project supplies, a paper towel or rag, and rinse cup for cleaning paint brushes.

Depending on the age and skill level of the painter, you may want to cover the work surface with newspaper or wax paper to prevent spills and make clean-up easier.

Steps

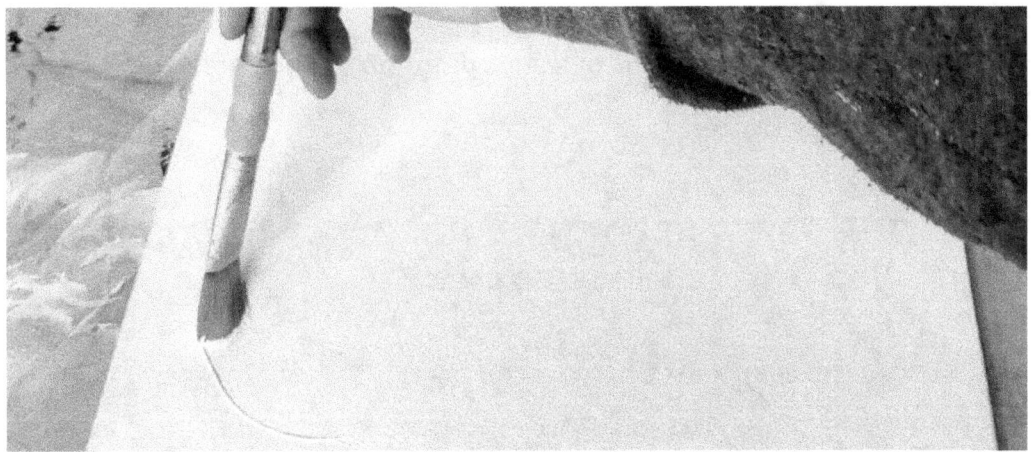

Step 1: Paint a Fade

For this tutorial, I opted for a white background with strokes of iridescence from a gloss medium.

This first step is optional but recommended. If time is limited, you may skip ahead to step two.

Paint the background of your canvas with white paint or light colors. Horizontal, vertical, and elliptical fades from a pale shade to white look fantastic, as does a large fading swirl and multiple faint swirls.

If you're unfamiliar with fading paint, you can achieve the same look by first painting all or part of the canvas in a pale color and adding white before the color paint is dry.

It's easiest to have two brushes ready when painting a fade this way. Start by pouring a small amount of your colored paint on the side of a paper plate or palate divot.

Then, pour a small amount of white paint on to the same plate or into a separate palate divot.

If you're using a paper plate palate, do not allow the colors to mix.

Next, add the color paint to your canvas.

Add white paint where you want the fade to begin before the color paint dries.

If you want some of the canvas to be flat white, refrain from adding color paint to this area of the canvas or wait until the color paint dries to cover it in one or more layers of white paint.

If your paint looks too thick, darkly, or appears to glob in areas, spread and flatten the paint with a dry paintbrush using short, light strokes.

When you're happy with the appearance of the background, set your canvas aside to dry.

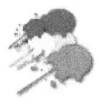 **To decrease dry time, refrain from using excessive amounts of paint on the background.**

The more paint used and the thicker the layers of paint, the longer the dry time.

Step 2: Sketch a Tree

Once your canvas is completely dry, or if you opted to skip painting a fade in the background, lightly sketch the silhouette of a tree.

It can be helpful to search for images of tree silhouettes prior to starting your sketch.

The silhouette should include the trunk, main arms, and some branches of the tree, but not leaves or twigs.

> **Experienced painters can skip the sketching and go directly to painting the tree trunk, if desired.**

There are multiple ways to make a beautiful tree silhouette.

Option 1: Sketch

Sketch a tree silhouette onto the canvas.

If you are having trouble conjuring the image, print or look up one for reference while sketching.

The branches are the most difficult part, but since they will be covered by bottle-bottom prints later, feel free to keep them simple and scarce.

As long as your pencil strokes are light, you should be able to erase mistakes prior to painting.

If you're unable to erase, you can paint a background layer to cover the mistake or cover the entires canvas if you wish to start over.

Option Two: Print, Cut, Trace

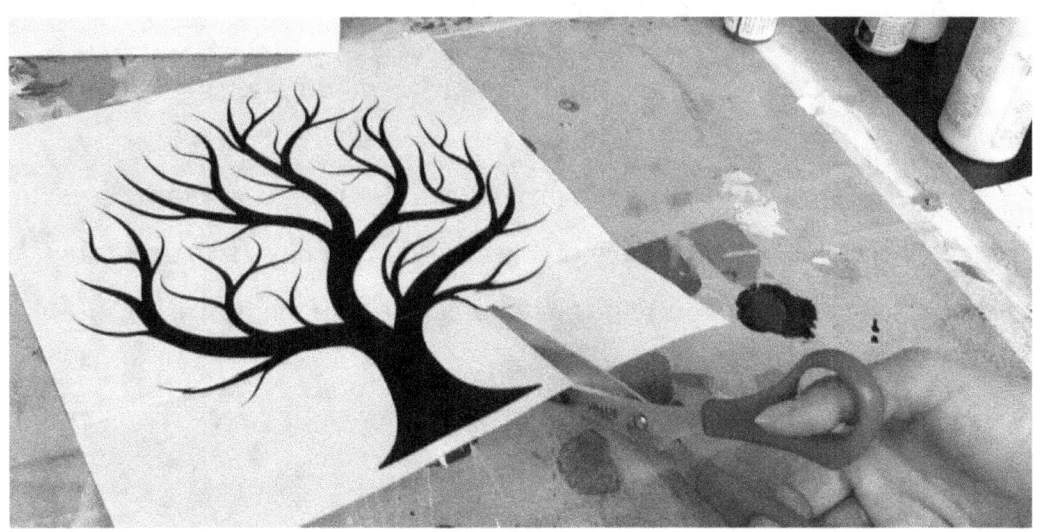

If you're like me, you love art but you also want it to look great. Maybe you aren't naturally artistic.

You can find an image of a tree silhouette online and print it out. Depending on the size of your canvas, you may want to enlarge the tree so half of it prints on one page and the other half on a second page.

 If you don't have photo editing or graphic design software, use a word processing program to edit the image.

Once inserted, increase the size of the image so that only half or part of it can be seen on page one, then insert a second page and duplicate or copy-paste the image from page one.

The image will remain the same size when duplicated or copy-pasted onto page two but will reset to the original size if inserted on page two.

Bear in mind that both images need to be the same size to line up later on

If you are not able to scale size to a tenth, avoid inserting the image.

Adjust the frame of the image or position the image so that the parts of it that were showing on page one are hidden on page two and the parts that were hidden on page one can be seen on page two.

Then set your printer to borderless and print both pages. Thicker paper works best, but any weight will do.

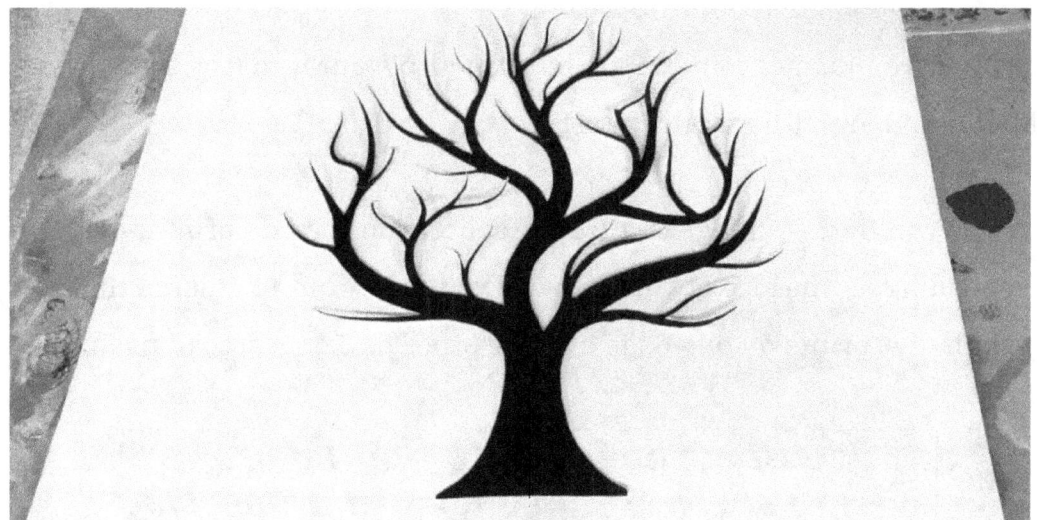

If the silhouette you chose has significant detail, it may be easier to line up both pages and tape the two pages together prior to cutting.

In general, it's easier to cut each of the two sections out individually and line them up on the canvas.

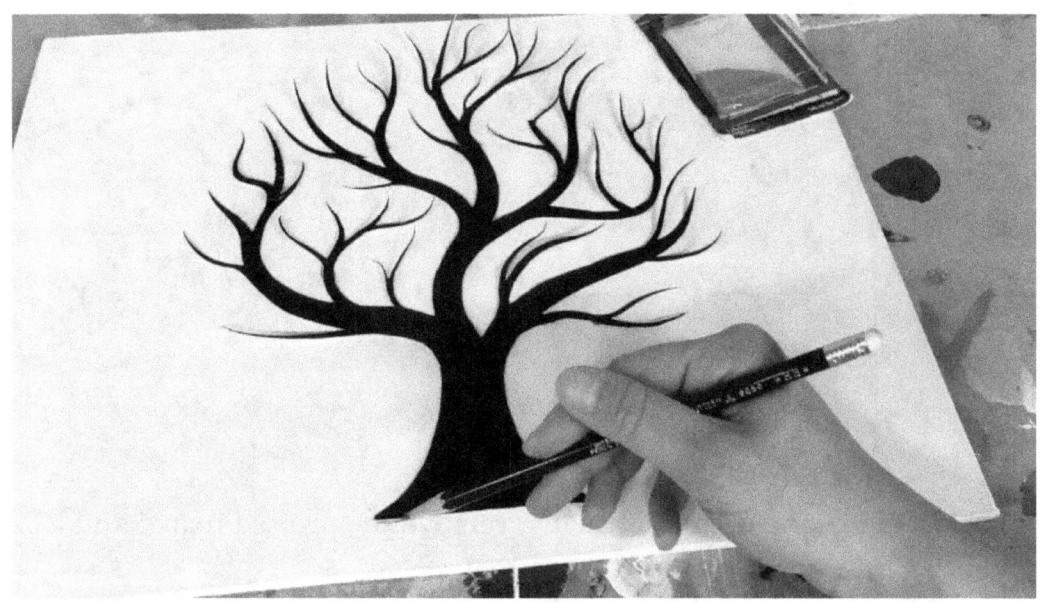

Place the cut-out tree silhouette on the canvas and line-up both sections.

Place a small piece of poster tack over the area where they connect to prevent movement while tracing.

If your silhouette is relatively simple, or if a more detailed one is printed on heavy stock paper, you should be able to hold your new stencil in place as you lightly trace around it.

However, if you opted for a more intricate design printed on standard copy paper, you may need to attach it to the canvas using blue poster tack or a similar easily removable, non-permanent adhesive.

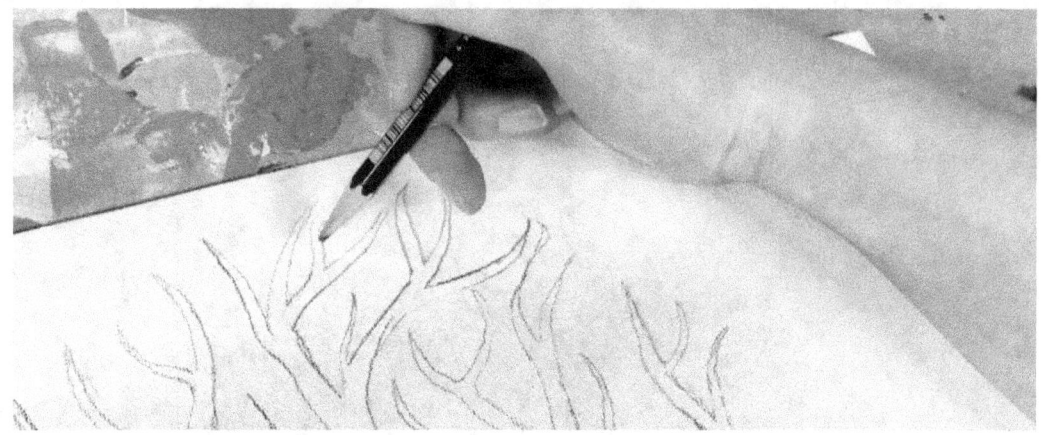

Once you're done with the tracing, remove the printed image and look over the traced outline.

Add touch ups where needed.

Option Three: Hard Trace Indent

Follow the above method for printing an image of the tree silhouette.

Once printed, line up both pages on the canvas. Tape the images together. Secure the full print-out in place with scotch tape on parallel sides.

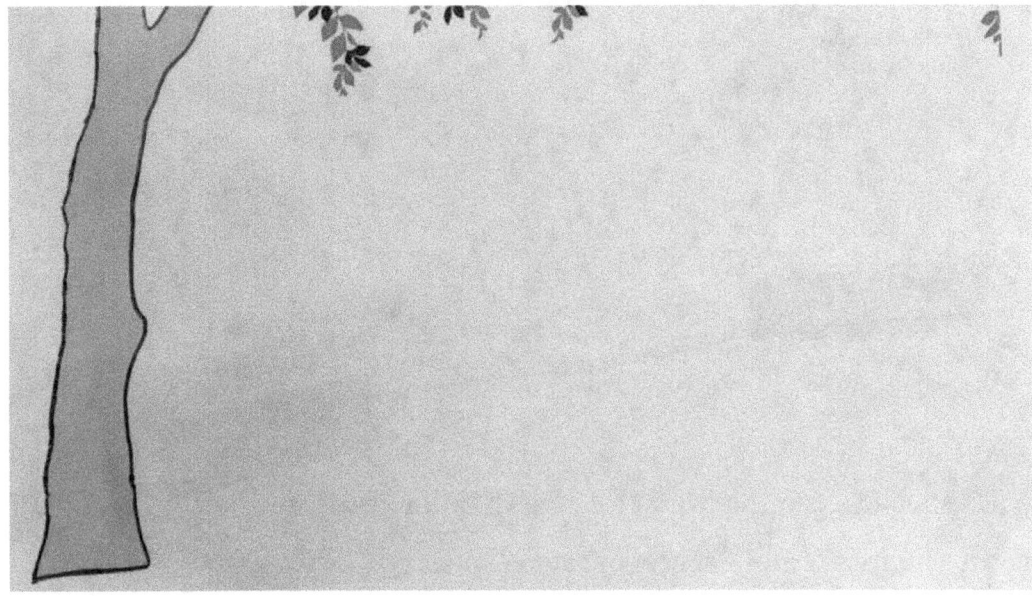

Then, using a sharpened pencil with a dull point and pressing hard, trace the printed image.

When the entire image is traced, gently remove one piece of tape.

Lift the printout so that you can see the canvas or paper below it, but without fully removing it.

There should be a silhouette of the tree indented in the canvas paper.

 You can trace around the image many times to create a stronger indentation.

If you don't see one, re-secure the printout and trace over it again with increased pressure.

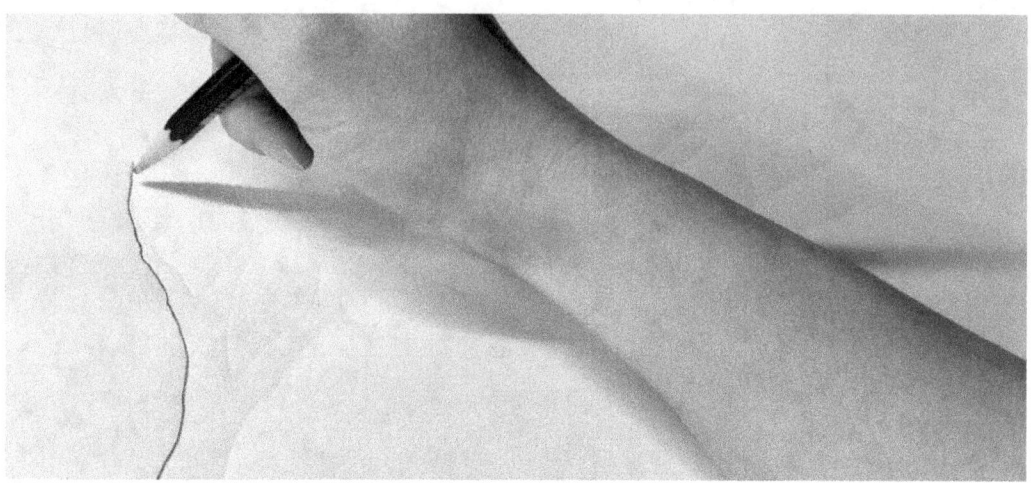

Remove the printout. Trace along the indented lines lightly in pencil or use them as a guide when painting the tree.

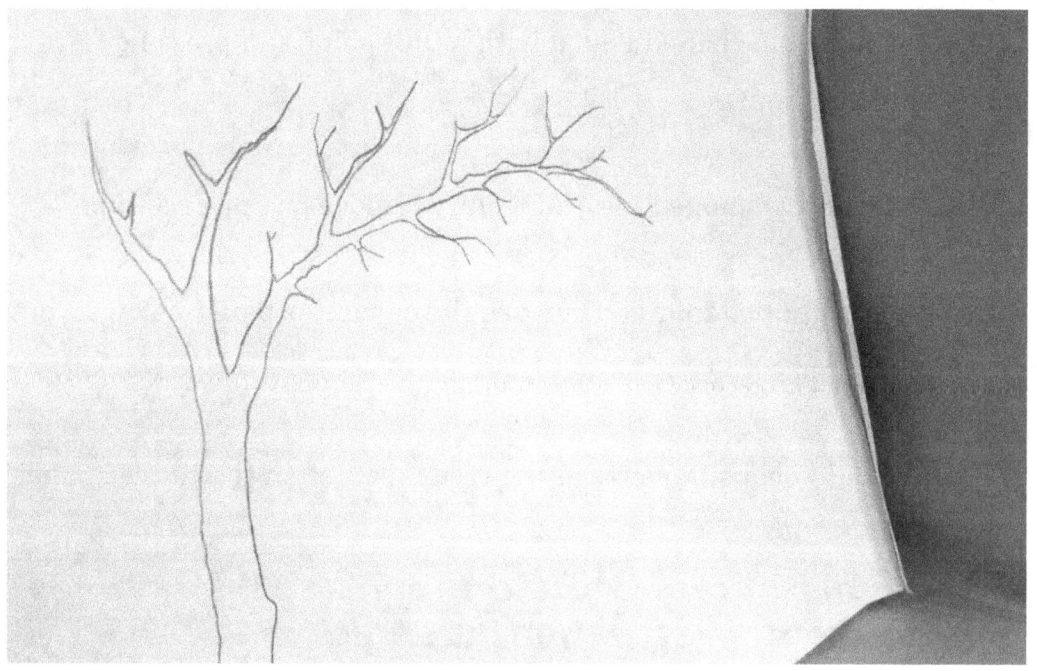

Step 3: Painting the Tree

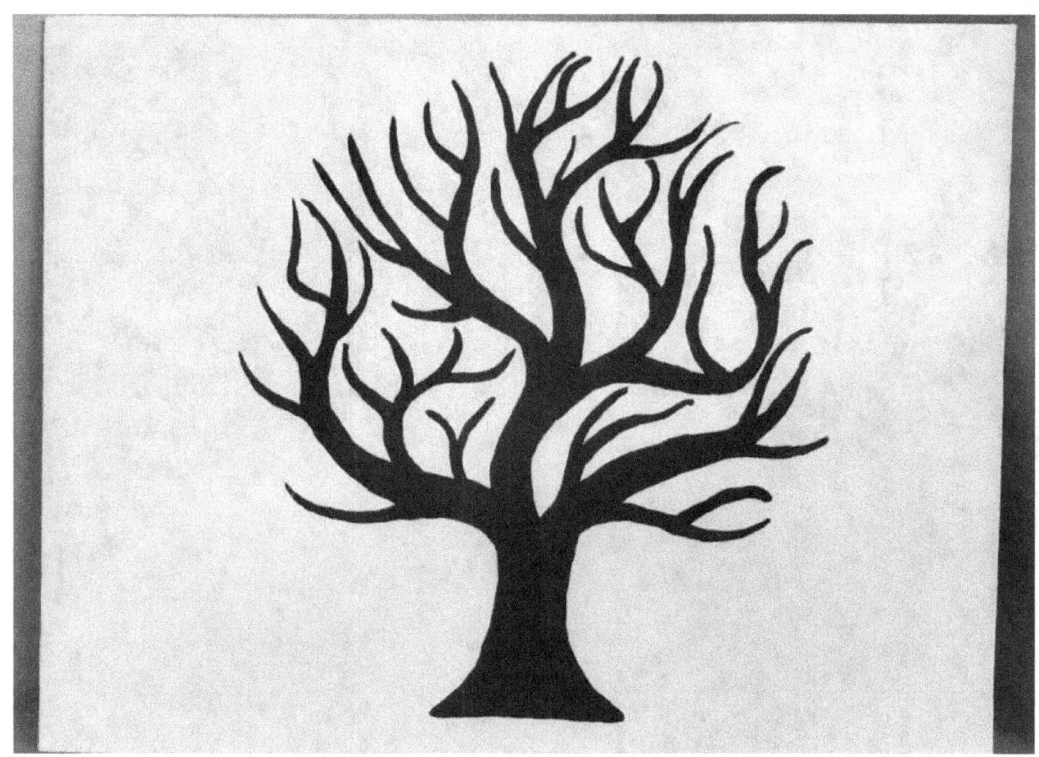

Using the black or brown (or your color of choice) craft or tempera paint, paint inside the silhouette of your tree.

 For quicker dry times, paint in thin coats. Allow the paint to dry between coats.

Then set the painting aside for 10 to 20 minutes to dry, depending on the thickness of the paint and the humidity level in your environment.

Step 4: Prepare to Stamp

While tree silhouette is drying, wipe the bottom of your soda bottle to remove dust and debris.

 Use a piece of scrap paper. Try to conserve your resources!

Prepare a paper plate with the color paints you want to use for the leaves and flower prints.

Step 5: Leaf Prints

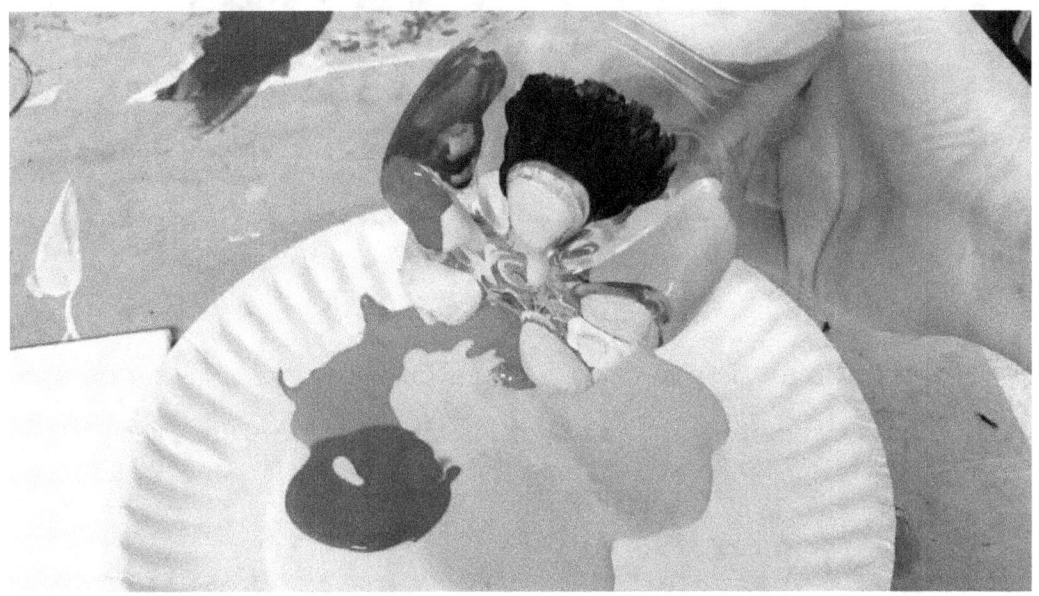

Dip the bottom of the bottle in the paint pool on the paper plate.

Lift the bottle straight up, then gently stamp the painted end on the scrap paper to remove excess paint.

Now you're ready to start stamping leaves or flowers onto your tree silhouette.

 Be as creative as you want to be! Use many colors- or one!

You can use as many or as little stamps as you would like and add as many or as little colors to your stamp pad.

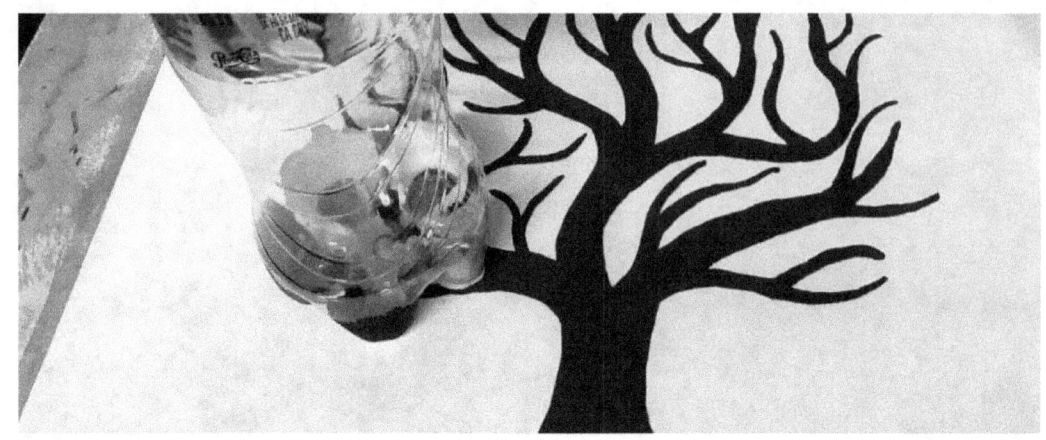

Dip the bottle in the paint pool again after a few times of stamping the tree limbs. Stamp again and again until the tree reaches the desired fullness.

Step 6: Dry Time

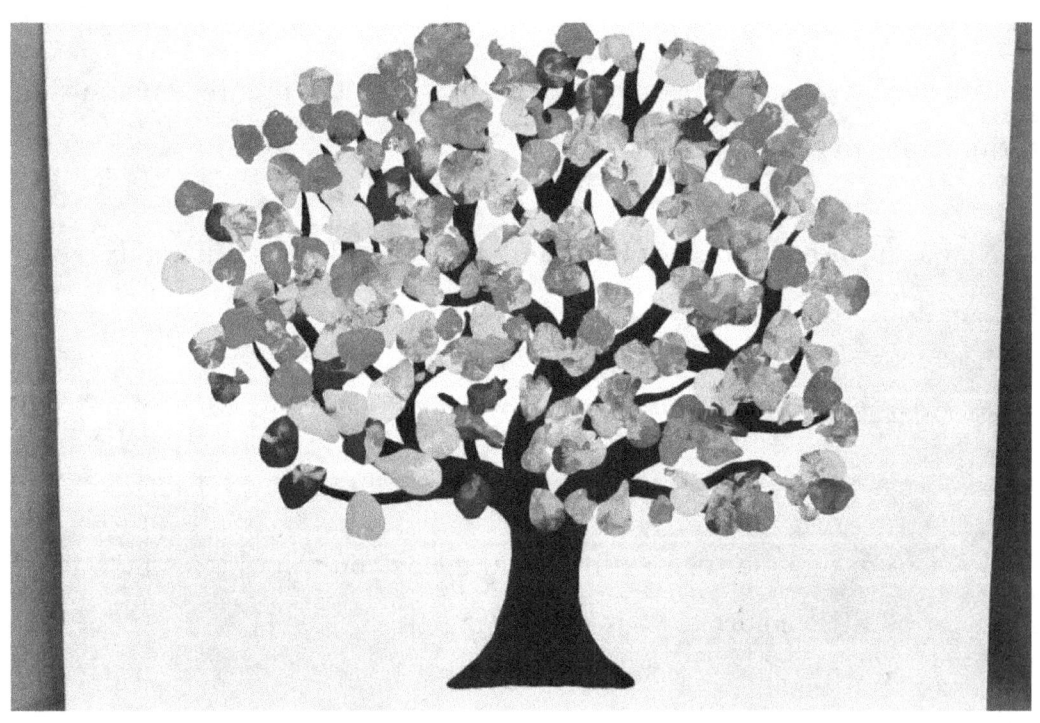

Allow to dry overnight if needed.

Once dry, make touch-ups, if needed.

When complete, hang and enjoy.

Decorative Beans

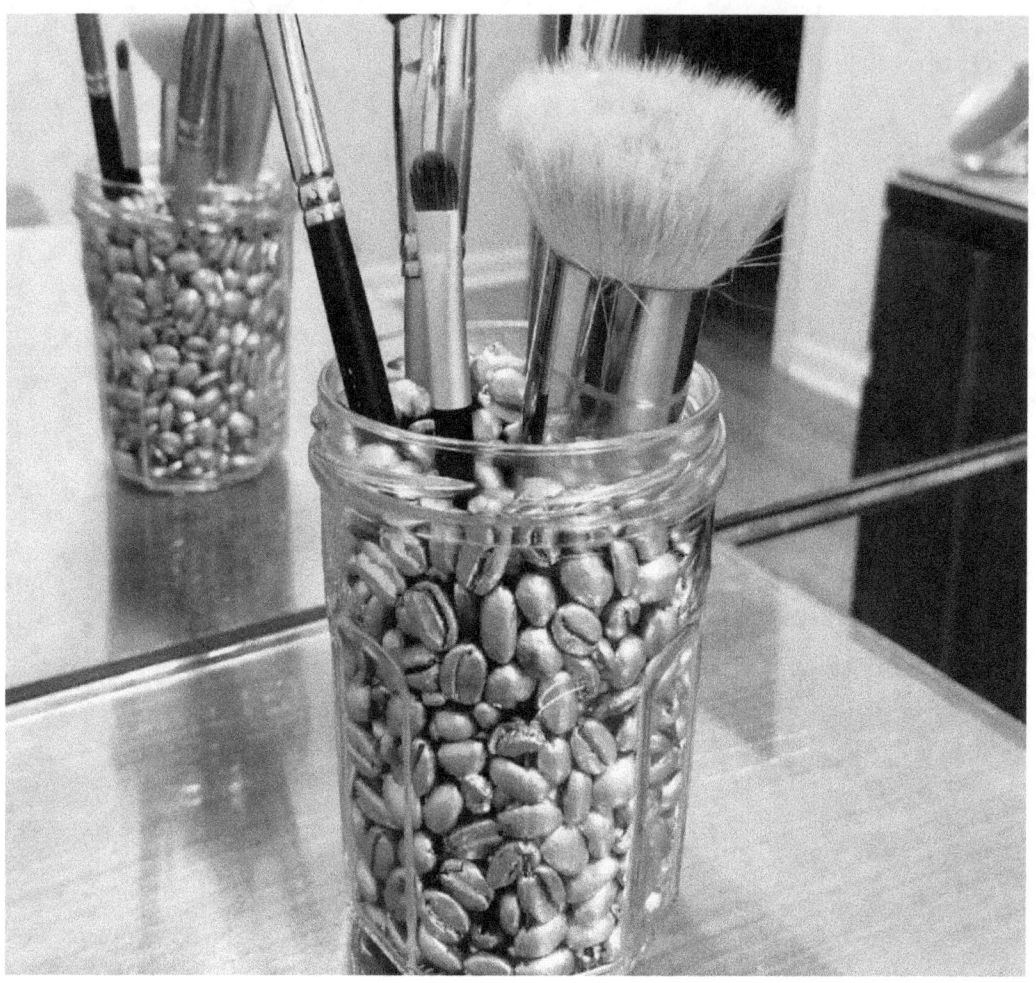

Skill Level: Easy

This is an easy home decor project, better suited for adults and older kids.

Supplies

- Coffee Beans

- Tarp or Large Rag

- Disposable Trays (3-4)

- Quick Dry Metallic Spray Paint

- Plastic Gloves

Preparation

Place a tarp or large rag on the ground or over your work surface. Secure the covering with heavy objects or tape to prevent the edges from flapping around in the breeze.

Since this project involves spray paint, it should be done outdoors or in a highly ventilated area, such as a workshop or garage with the door open.

Steps

For best results, follow the recommended temperature and humidity guidelines on your can of spray paint.

Strep One: Scattering the Beans

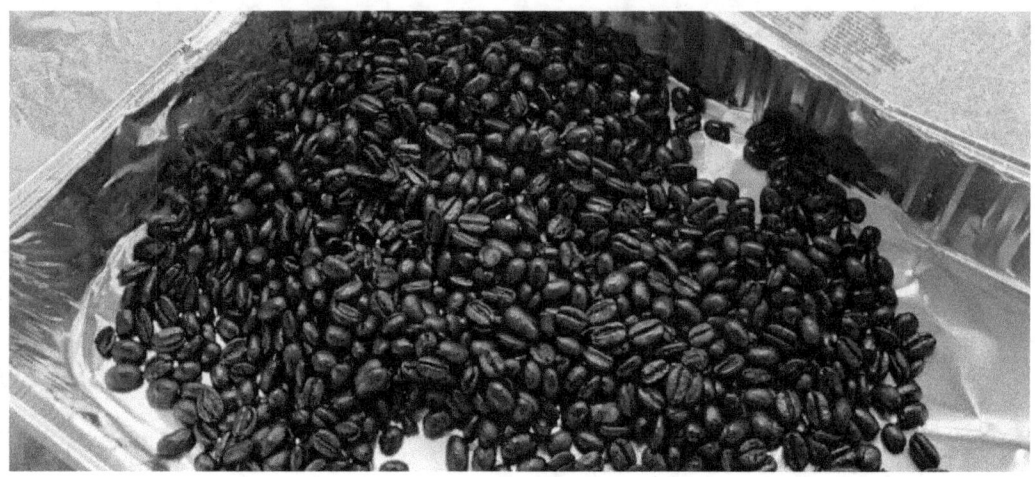

Sprinkle a handful of coffee beans on a disposable tray, sifting through them to remove broken pieces and debris as you drop them.

Repeat, making sure they do not overlap each other until the tray is covered.

Step 2: Spraying the Beans

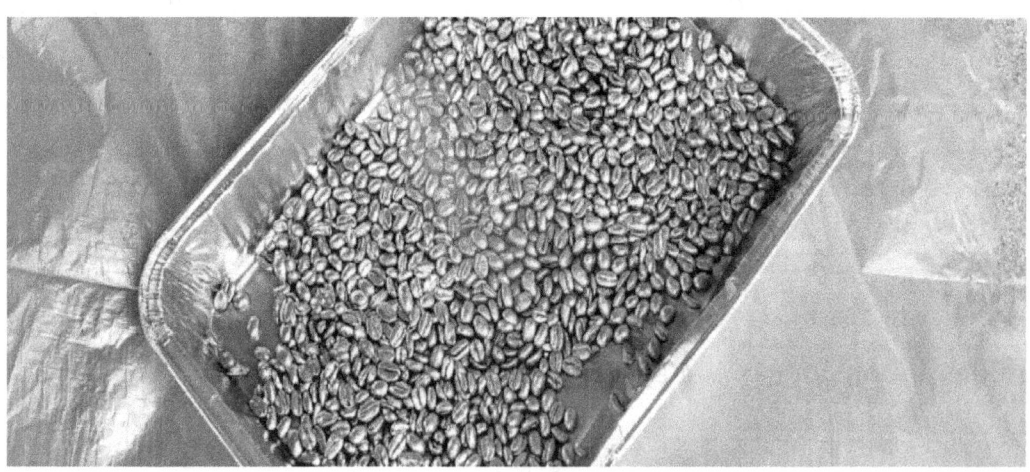

Put on the plastic gloves and spray the beans from about a foot away. Sweep the spray can steadily from one side of the tray to the other and back again until all the beans are coated in metallic paint.

 Vigorously shake the spray paint can for about one minute before each use for an even mist.

Set that batch aside. Sift through the remaining beans, scattering them into a second tray. Spray the coffee beans in the second tray in the sa me side-to-side, gently sweeping motion.

Step 3: Dry and Spray Again

Allow 15 to 20 minutes of drying time, then apply a second coat of paint to both trays.

Wait for 15 to 20 minutes after applying the second coat to transfer the trays indoors to dry overnight.

Step 4: Spray the Underside

After your beans have dried completely, empty the contents of the first tray into the unused third tray.

While wearing plastic gloves, flip any beans that land with their painted side up, so that the unpainted section is exposed.

Spray the unpainted underside of the beans using the same side-to-side sweeping motion. While they dry, empty the beans from the second tray into the now empty first tray.

Arrange them so their unpainted underside is facing upward and apply more paint.

 Use a respiration mask if you are susceptible to paint fumes.

Once the entire tray is coated, set it aside and spray a second coat on the beans in the third tray.

Wait 15 minutes and apply a second coat of paint to the beans in the first tray. Then carefully transfer both trays to a sheltered drying spot.

Step 5: Dry and Sort

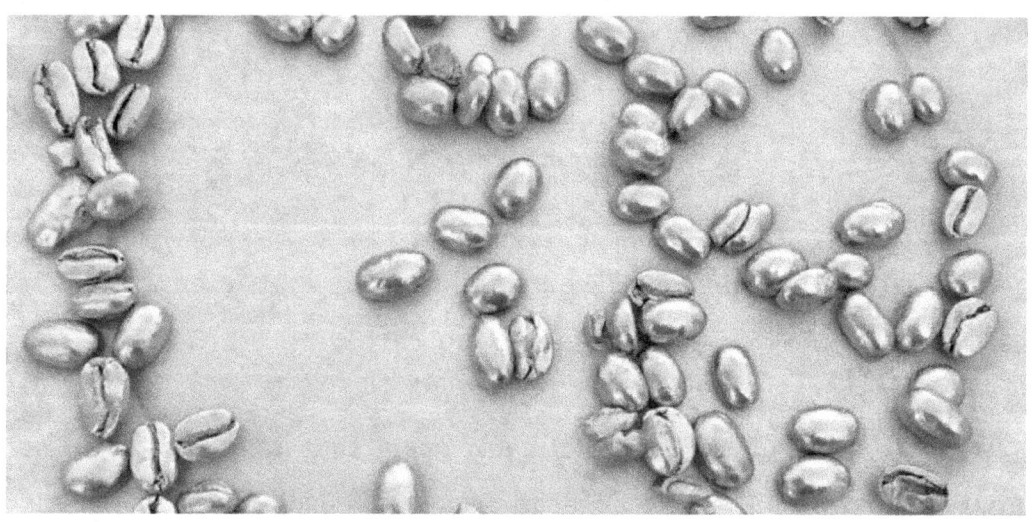

Allow the beans to dry for at least eight hours or overnight if possible.

Depending on the humidity, the beans should be ready to be handled in 8 to 12 hours.

 You might want to wear plastic gloves for this next part.

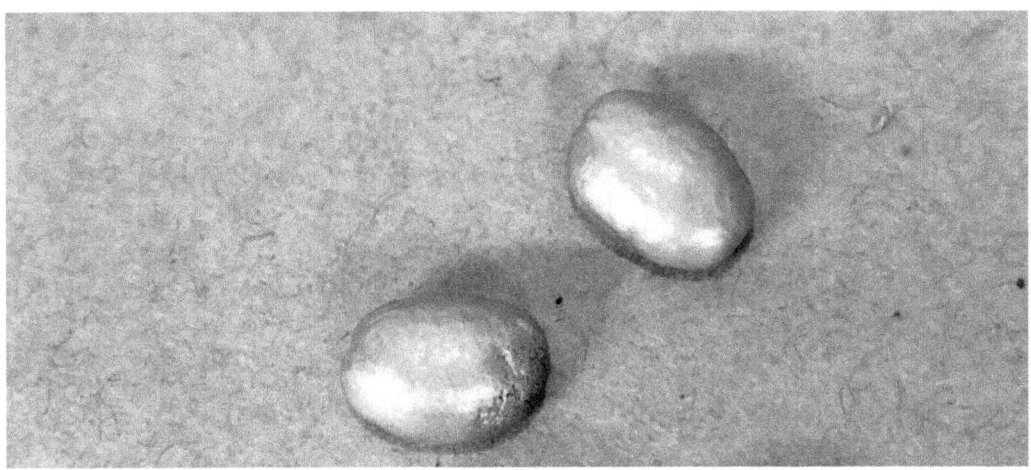

Sort through the beans, by sifting them around in the tray and removing beans that still have unpainted spots.

Step 6: Repaint as Needed

The majority of the beans should be completely coated, but inevitably some of them will need a third coat.

Place the beans that need a third coat, with the unpainted section facing upward, into the empty tray and set it aside.

Sift through the finished beans, double checking for bare spots as you place them into your vessel of choice.

Depending on the number of beans that require a third coat, you may want to apply another coat after you have finished sorting them.

Set them aside to complete at another time or toss them in the trash.

Step 7: Place them in a Vessel

Some ideas for how to display the beans:

- In a mason jar

- In an old, cleaned out spaghetti or jelly jar

- In a decorative basket

- In a cool painted flower pot

- In a clear fish bowl

Enjoy the look of decorative beans as a centerpiece, bookend, or however they bring you pleasure.

Record Bowl

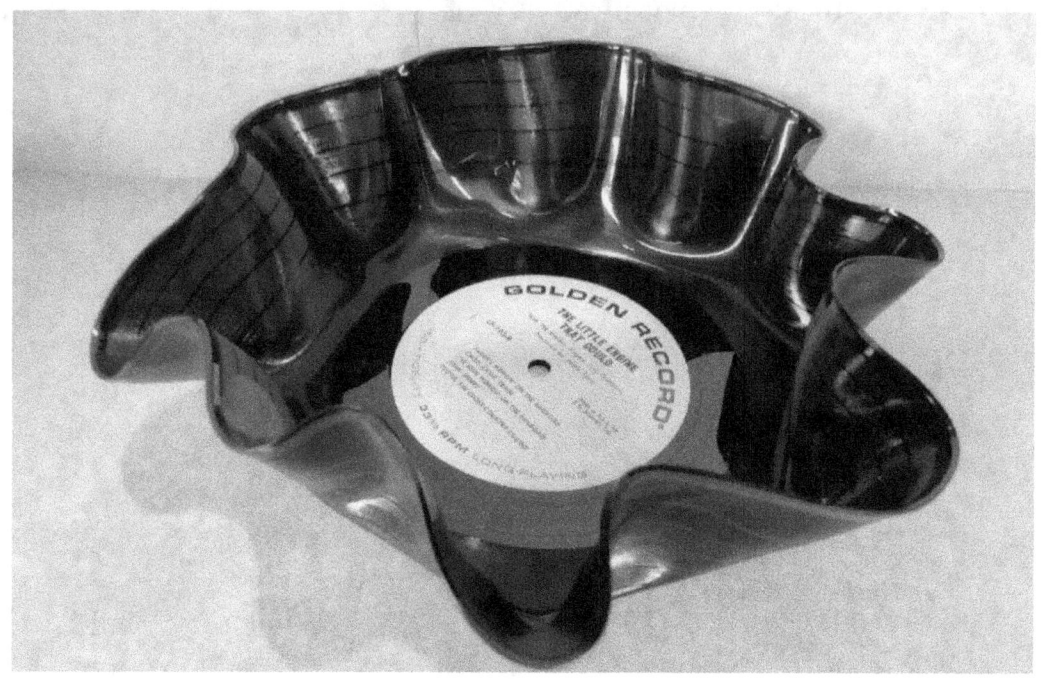

Skill Level: Easy

This is a quick and easy project, best for teens and adults

Supplies

- Old Record

- Oven Mitts

- Large Pot or Wok

Preparation

Gather a record, large pot, and oven mitts.

> **The record will no longer be playable once you start step two!**

Using a microfiber cloth, carefully clean a 12-inch record.

Steps

Bye-bye, old scratched LP. Hello, beautiful bowl!

Step 1: Heat a Large Pot of Water

Fill a large pot or wok about one-half to two-thirds with water and place it on the stove on high heat.

When the water is warm enough to generate steam, reduce the heat to medium-high.

> *Water should be hot enough to generate steam, but not simmering or boiling.*

Step 2: Warming the Vinyl

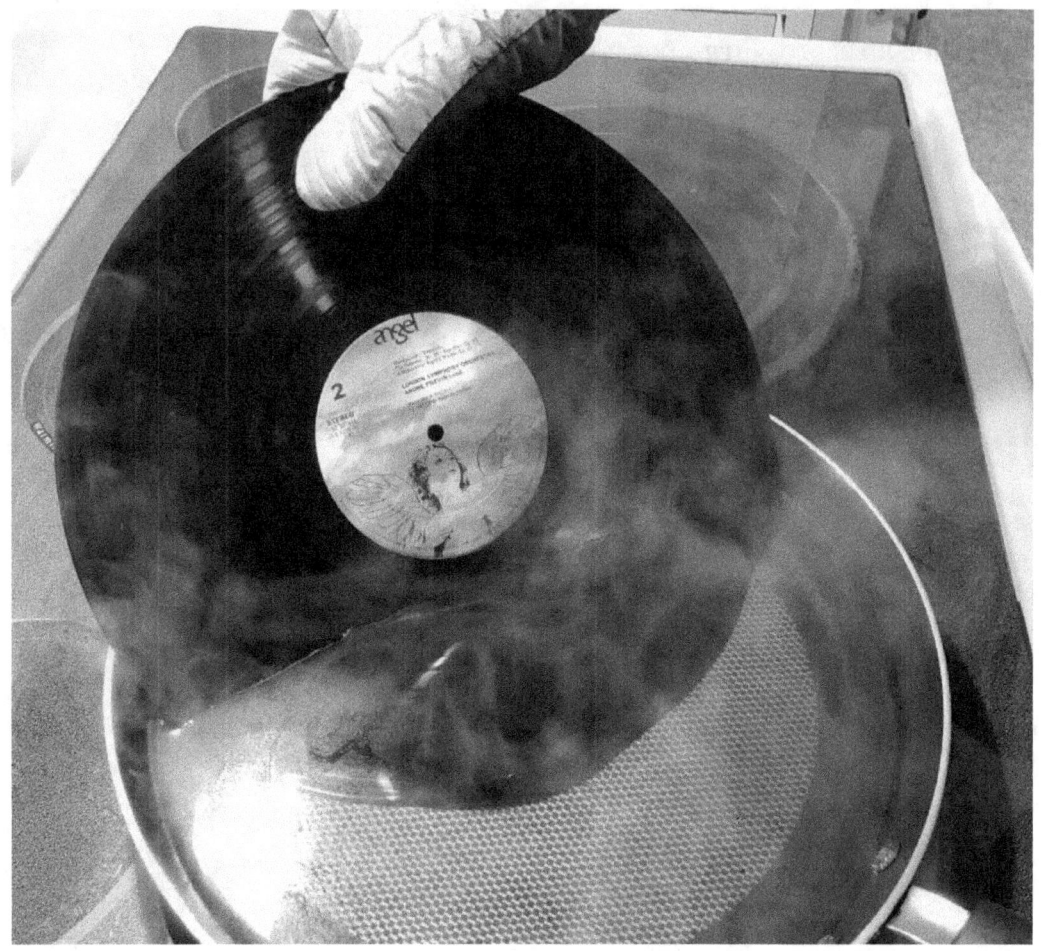

While wearing oven mitts, place one side of your record into the water.

The water should cover most of the vinyl on the submerged side and go up to about a half-inch below the label in the center of the record.

Hold the record upright in the water until the submerged vinyl becomes malleable. The vinyl should begin to curve and appear supple.

Step 3: First Pinch

Lift the record from the water.

Place your thumb and fingers about one-and-a-half inches apart on the outer edge and pinch the vinyl to form a curve.

 This step needs to be done quickly because the vinyl will not be moldable for long!

Once removed from the water, the record will begin to cool and harden.

Remember it's okay if the first pinch isn't perfect, it can be redone as many times as needed.

You may want to redo it once or twice at the onset, but don't spend too much time trying to perfect the first cinch, as you will likely want to make adjustments when all cinches are complete.

Step 4: Rotate, Warm, and Pinch

With the cinched edge just above the water's surface, submerge the next section of the record.

The cinched edge may start to open a bit.

If this occurs, rotate the record so it is slightly farther from the surface of the water and pinch it again while part of the record is still submerged.

When the submerged section of the record becomes malleable, remove it from the water.

Holding your fingers the same width apart as before, pinch the outer edge to form a curve.

Step 5: Rotate, Warm, and Pinch Again

Submerge the next section of the record, removing it from the water and pinching the sides when it becomes bendable.

Step 6: Repeat

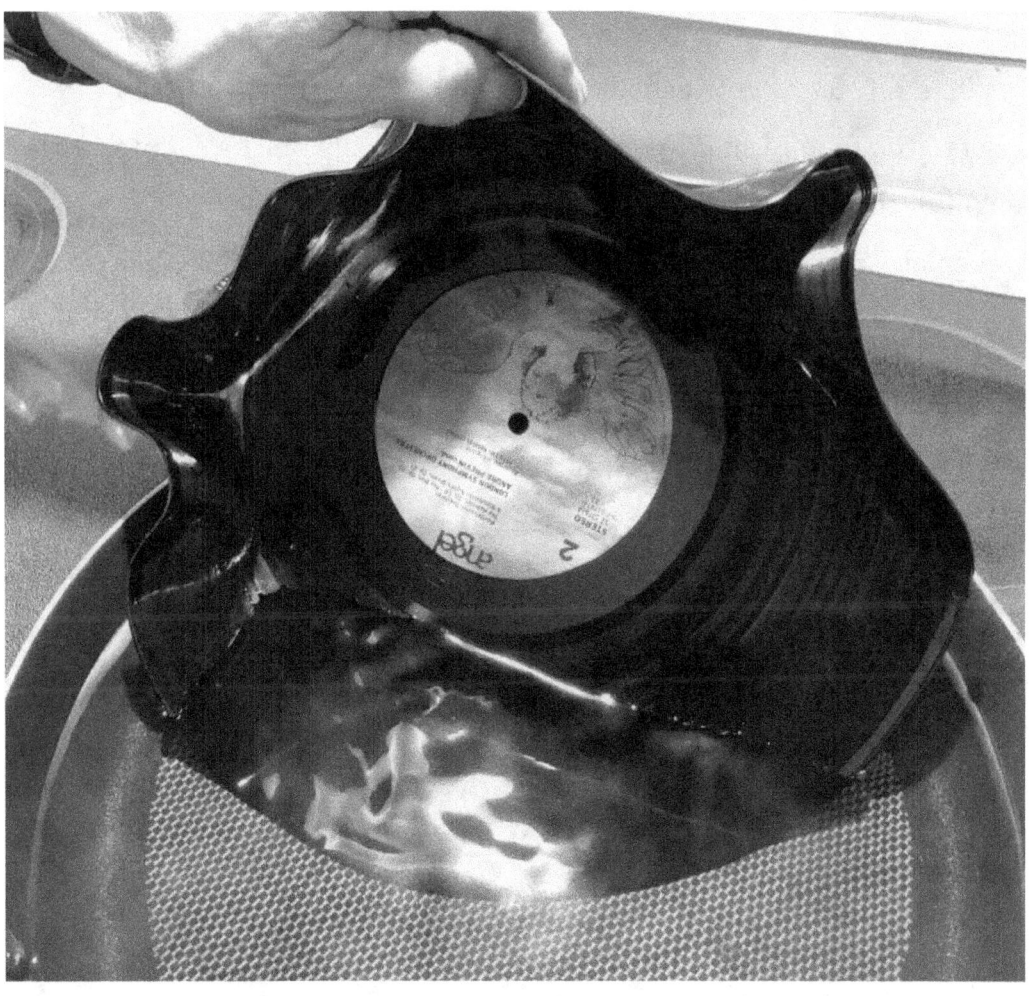

 The bottom of the bowl, which is the label and the area directly surrounding it, should be flat.

Continue rotating, submerging, and pinching until you have about nine cinched edges and the sides of the record tilt upward to form a bowl.

Step 7: Touch-ups

When all edges are cinched and the record has formed into a bowl, observe the final form. Pay attention to how it sits on the counter, the height of the walls, and the degree or angle of the cinches and curves. Make note of areas that need to be reworked.

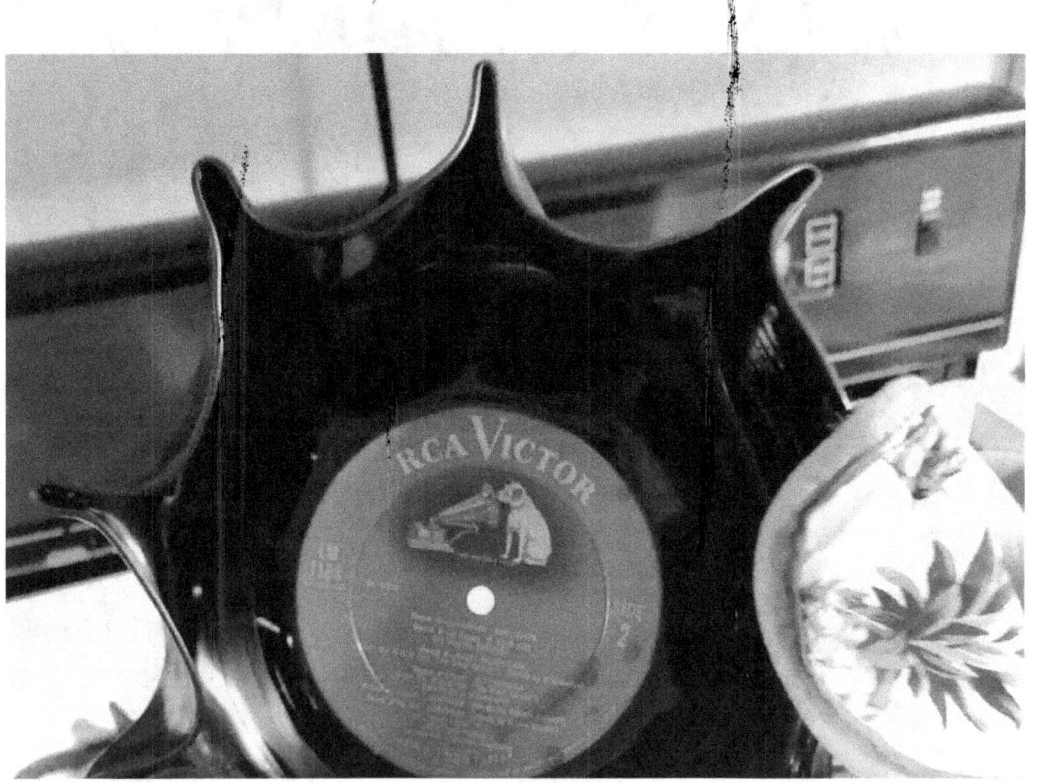

Then submerge where needed and adjust accordingly.

Step 8: Final Inspection

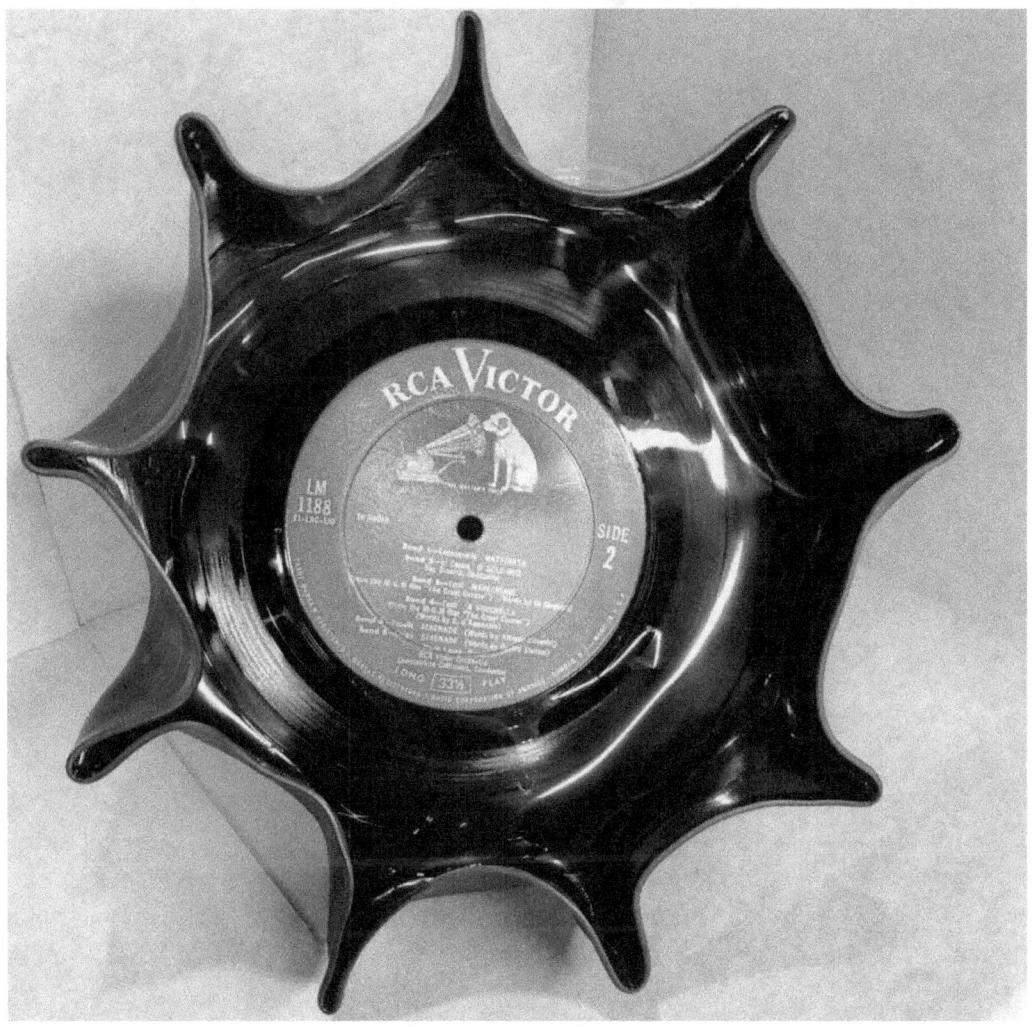

After completing final touch-ups, dry the record bowl with a microfiber cloth and set the vinyl aside.

Allow 3 to 5 minutes for cooling time before filling it, wrapping it, or otherwise using the bowl.

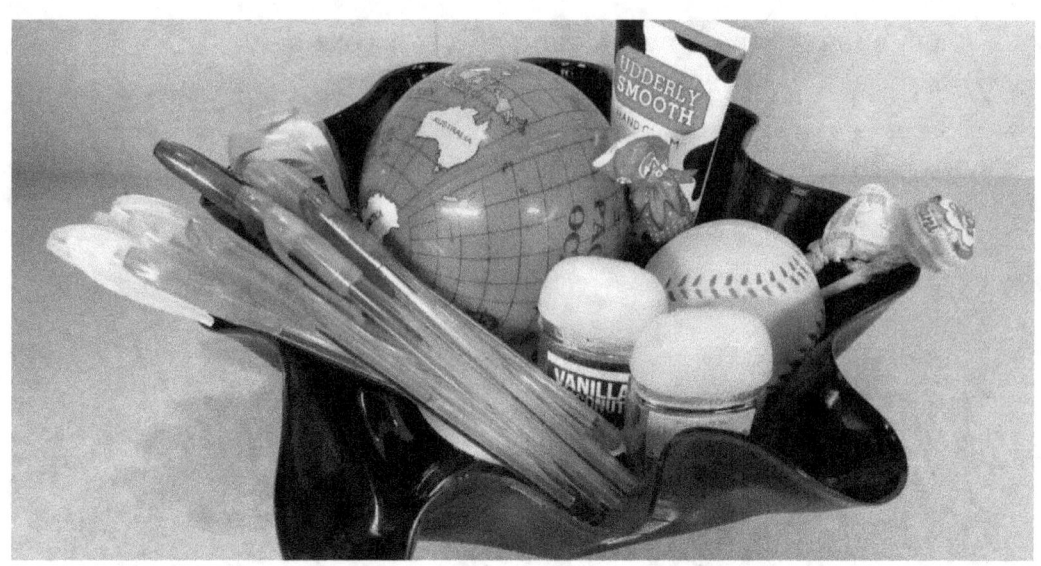

Enjoy using your record bowl as a statement piece, desk organizer, junk shelf bin, fruit bowl, or for anything you want.

Can Candle

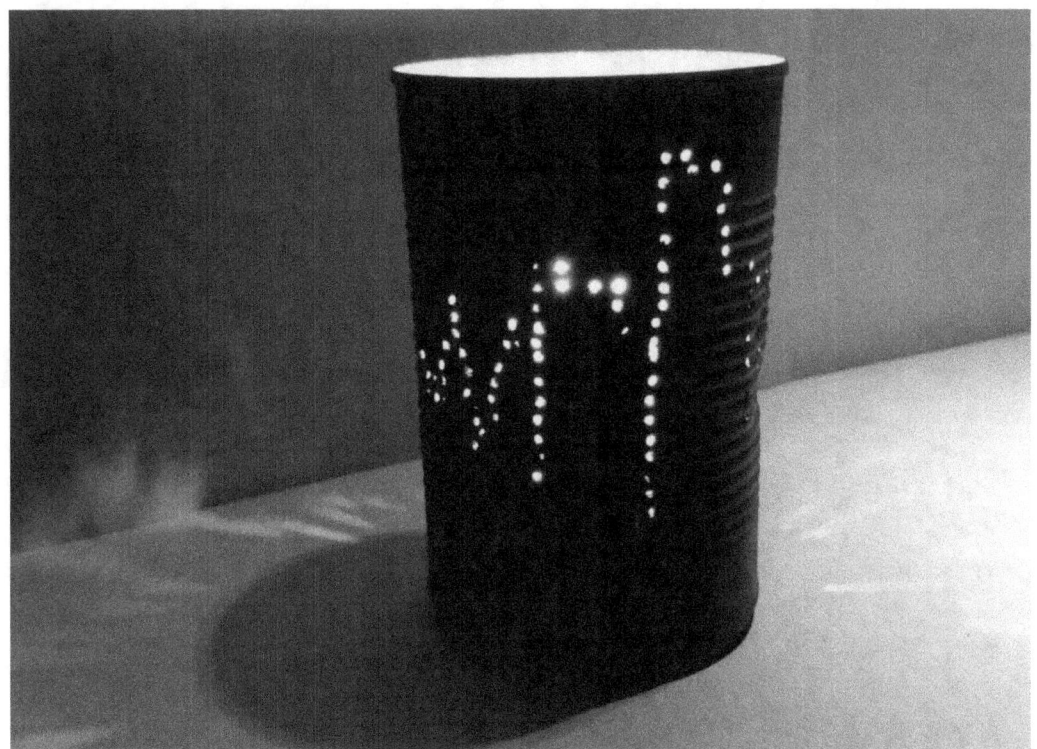

Skill Level: Easy

This project is only a tad bit more complicated than carving a pumpkin, however, it does require a power tool.

Best for adults and teens.

Supplies

- Clean and empty food can(s)

- Sharpie

- Electric Drill

- Various Drill Bit

- Craft, Acrylic, or Spray Paint

- Oven Mitt or Leather Work Glove

- Toothpick

- Foam Brush and Top Coat (Mod Podge)

Preparation

Remove the labels from the empty cans and thoroughly clean them.

Take care to ensure there are no sharp edges around the opening.

If sharp edges exist, sand them down then carefully rinse any metal shavings and dust from the can.

 The cans should be free from any lingering food odors.

Set cans aside to dry.

Steps

For this project, consider line dot art or a freeform design.

Step 1: Decide and Dot

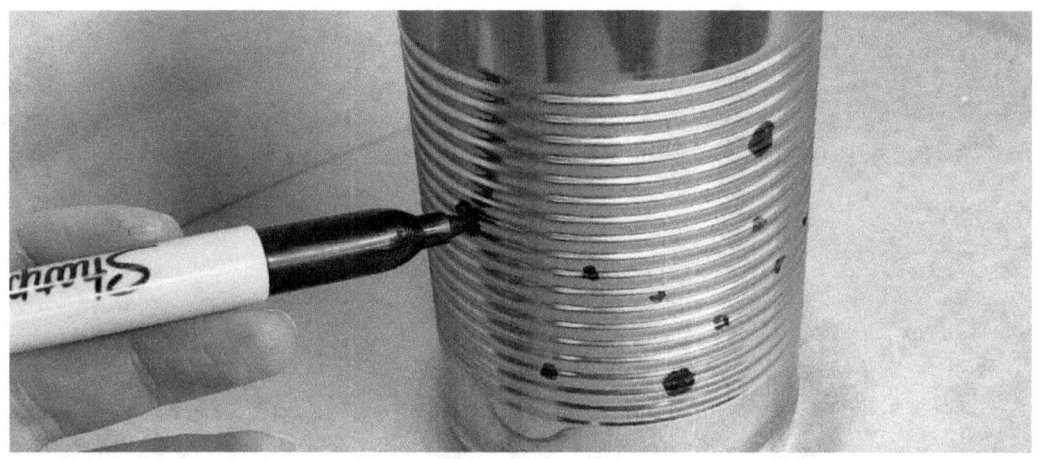

While the cans are drying, determine a design, word, or image for each can.

You can place random holes around the can, spell out a word, or outline a shape.

Once you've determined your design, use a black permanent marker to mark where to drill holes.

Be sure to indicate which, if any, holes should be larger or smaller by the size of the dot you draw.

 Your imagination is the only limit but simple shape or silhouette image works best.

This step is pretty easy to do when making words, random designs, and constellations like the one in the sample image above.

It can be difficult for creating more complex shapes and designs.

If you are unable to get the dots just right, print an image.

Cut the printed shape out, tape it to the can, and make a dotted line around it.

Step 2: Drill the Holes

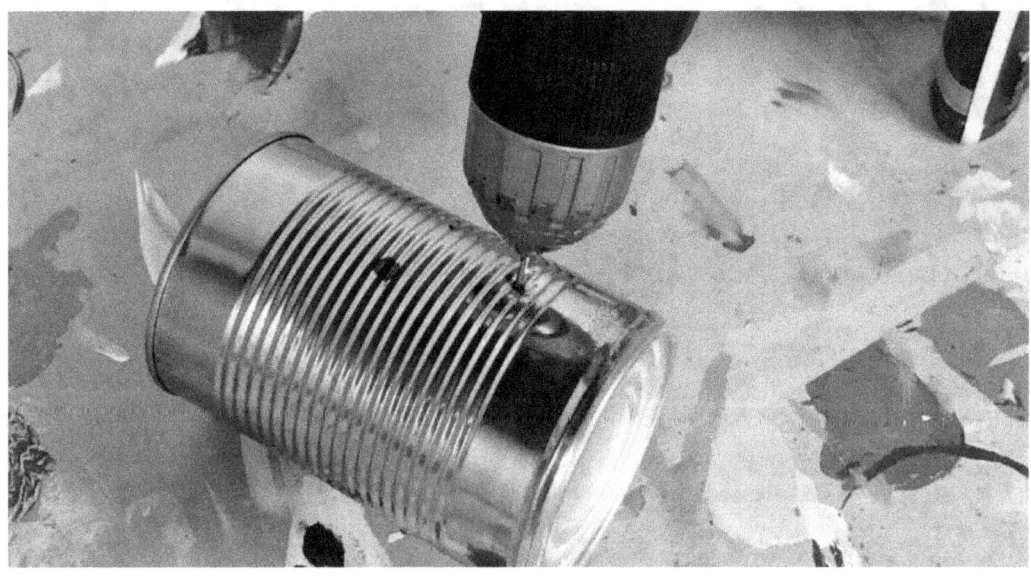

Once your dots are in place, secure the can in a vice or firmly hold it in place.

Begin drilling, using your dots as a guide.

 Use an oven mitt or work glove to hold the can to reduce the risk of skin abrasions.

If you are using multiple drill bits, make all holes for that size bit before moving on to the next size.

Step 3: Inspect and Touch-Up

Inspect the holes for obstructions. Drill again through any holes that lack clean edges or are partially blocked.

All your holes should be clearly visible and clean of debris.

Step 4: Paint

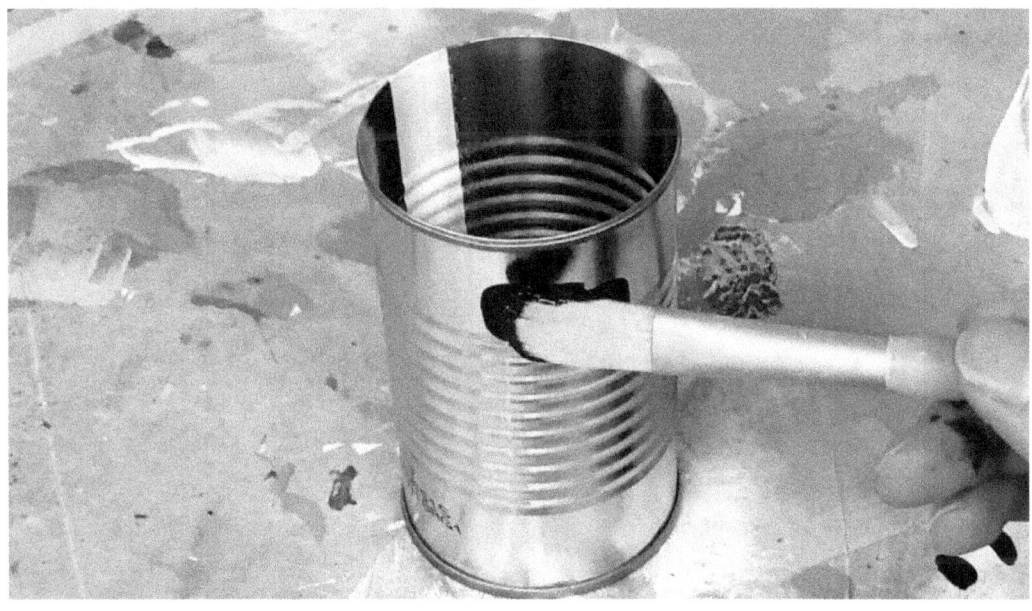

Use a rag to remove any drill shavings from the can.

Paint in a color or design of choice using craft, acrylic, or spray paint.

For this example, I used craft paint and opted for a solid black background to go with the Virgo constellation design, but the finished design looks cool in any color or mix of colors.

When painting a solid color, paint with your can upside down so that the opening of the can is against the surface of your work area.

This will allow you to apply the first coat to all of the exposed surfaces in one sitting.

If you are painting a design that requires the can to be upright, paint the sides of the can first. Then, when the sides are dry, paint the base.

 If you have leftover paint and want to save it for the second coat, place the paint along with a wet sponge in a covered container.

Once the first coat is complete, allow the can to dry for 1 to 2 hours, depending on the humidity level of your environment.

Step 5: Second Coat

Once the first coat is dry to the touch, use a toothpick to remove any paint that is obscuring the holes.

Insert a toothpick all the way through each hole and circle it along the inner rim to remove any excess paint.

Once all the holes are cleared of any obstructions, apply a second coat of paint.

Set the can aside until it is dry to the touch and able to be handled.

Step 6: Touch-Ups

When the second coat of paint is dry, use a toothpick to clear each hole, then inspect the can for exposed metal and retouch as needed.

Step 7: Top Coat

If you opted for spray paint or only plan to use the cans once, skip to step eight. If you used craft or acrylic paint and plan to use the cans more than once, add a top coat to prevent the paint from chipping.

 Mod Podge works great and doesn't require an outdoor application.

Using a foam brush, evenly apply a thin layer of top coat to the dried can.

Watch for clumping and take care to smooth out brush lines for an invisible finish.

Allow the can to dry.

Step 8: Final Inspection

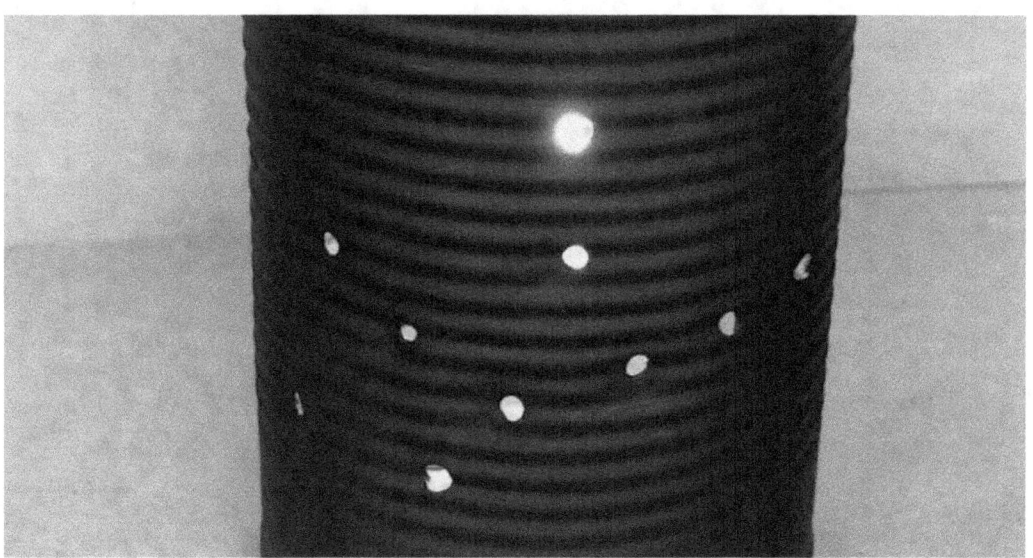

Use a toothpick to remove excess top coat that has covered over and inside the holes. Use a tea light candle in each can and dim the lights around you to look for hole obstructions you may have missed. Clear any obstructions using the toothpick or, if necessary, re-drill holes and touch up paint around them.

Text Silhouette Art

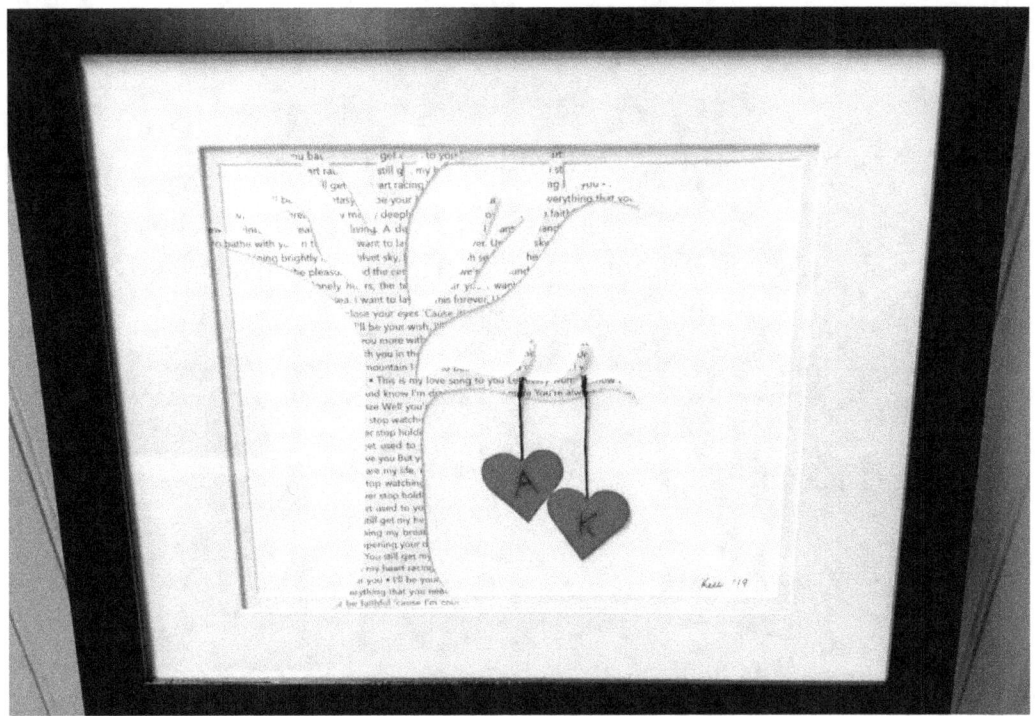

Skill Level: Easy

You don't need much artistic skill to create this stylish wall art. It can be styled to fit your personal taste or décor.

Supplies

- White or Light Colored 8.5-inch by 11-inch Card Stock

- Double Mat Board with 8-8.5-inch to 10-11-inch Opening

- Frame

- Color-of-Choice Card Stock

- 2 Sheets of Copy Paper

- Embroidery Thread (or similarly thick thread)

- Color-of-Choice Paint, Gel, or Permanent Marker

- Scissors

- Precision Knife

- Craft Bond or Multi-Surface Glue

- Computer/Printer

If computer and printer access is not available, you can use sheet music or printed text pages and spray glue.

Preparation

This art project makes for a unique and thoughtful gift. It's relatively simple to produce.

> ***Due to the detailed cutting involved, this chic project is best suited for adults and mature minors.***

On that note, opt for using a precision art knife for detailed backgrounds and cleaner lines.

Preparation for this project requires little physical work.

Steps

Other than gathering your supplies, all you have to do is decide the text you want in the background and the silhouette that will shape it.

Step 1: Make a Text Filled Background

unlimited potential. – Blake Crouch | We will hope that future historians will explain the morbid symptoms of present day society as the childhood ailments of an aspiring humanity – Albert Einstein | I ask no favor for my sex. All I ask from our brethren is that they take their feet off our necks. – Ruth Bader Ginsberg | The trip was to be an odyssey in the fullest sense of the word, an epic journey that would change everything. – Jon Krakauer | I've always known, on a purely intellectual level, that our separateness and isolation are an illusion. We're made of the same thing – the blown out pieces of matter formed in the fire of dead stars. – Blake Crouch | For a true writer, each book should be a new beginning where he tries again for something that is beyond attainment. He should always try for something that has never been done or that others have tried and failed. Then sometimes, with great luck, he will succeed – Ernest Hemingway | I saw the alchemy of perspective reduce my world, and all other life, to grains in a cup – Beryl Markham | We can have democracy or we can have great wealth in the hands of a few, but we cannot have both. – Louis Brandis | Citizens who are bound to take part in public affairs must turn from the pursuit of private interests and occasionally take a look at something other than themselves. – Alexis de Tocqueville | Footfalls echo in the memory down the passage we did not take towards the door we never opened. – T.S. Elliot | It's a beautiful thing about youth. There's a weightlessness that permeates everything because no damming choices have been made, no paths committed to, and the road forking out ahead is pure, unlimited potential. – Blake Crouch | As long as the population is passive, apathetic and diverted to consumerism or hatred of the vulnerable, then the powerful can do as please, and those who survive will be left to contemplate the outcome. – Noam Chomsky | We have never been a perfect union. Our finest moments have been when we sought to be more perfect than we had been. – Robert Reich | We will hope that future historians will explain the morbid symptoms of present day society as the childhood ailments of an aspiring humanity – Albert Einstein | I ask no favor for my sex. All I ask from our brethren is that they take their feet off our necks. – Ruth Bader Ginsberg

Text page example.

Open a document or new project in a word processing program, music writing software, or any similar application. Set the margins to zero.

Anything works for word choices here- song lyrics, poetry, personal messages, wedding vows, quotes, or sheet music.

Next, add any text of your choice.

Unless your text of choice already fills the length of the entire page, copy and paste it repeatedly until the entire page is filled from end-to-end with text.

Once the page is filled, print borderless onto white or light colored card stock.

You can sub in text or sheet music pre-printed on card stock. Use spray glue to attach an old book page to white or cream card stock. If you're a calligraphy aficionado, you can hand write the text on card stock.

Step 2: Prep Your Outline

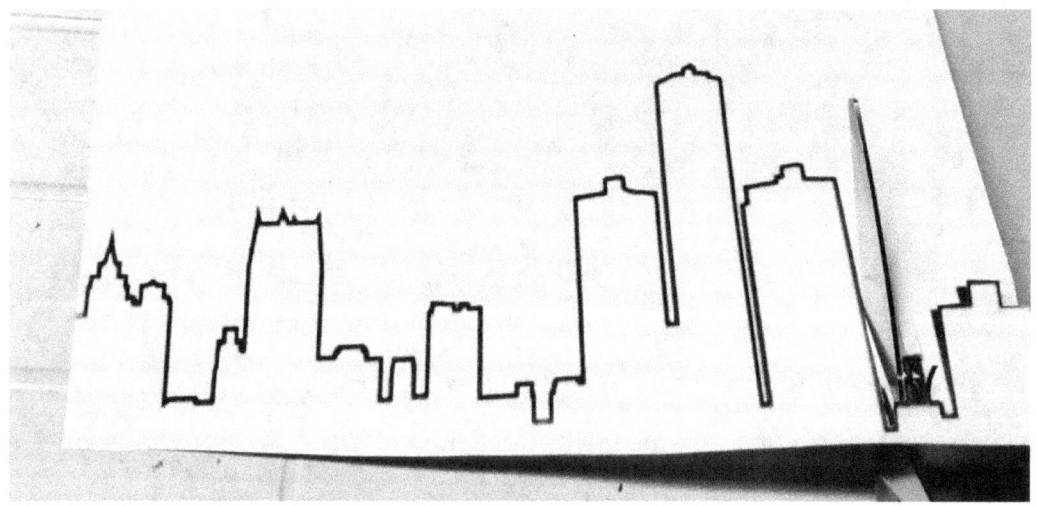

While the text background is printing or drying, prep the outline for your silhouette.

Trees, like the one in the sample image, work really well for this project. They reach from the top to the bottom of the mat board and their limbs make for great places to add accents.

It doesn't have to be a tree, however. For this sample, I'm working with a rough approximation of my hometown skyline.

Silhouettes that span from the top to the bottom of the mat board in one place and extend horizontally at the center are easiest to work with.

The only limit here is imagination and space. This isn't a literary project.

This is where that copy paper comes into use. Sketch or print the silhouette of your choice onto the copy paper.

When finished, cut it out and hold it up to the text that was printed on card stock.

The area you can't see (covered by the design) is where the printed text will appear when the project is finished.

You don't necessarily want to be able to read the text word-for-word.

If the silhouette is so thin that throughout most of it only parts of words are visible, then you might want to consider widening the silhouette spaces a bit.

Step 3: Trace

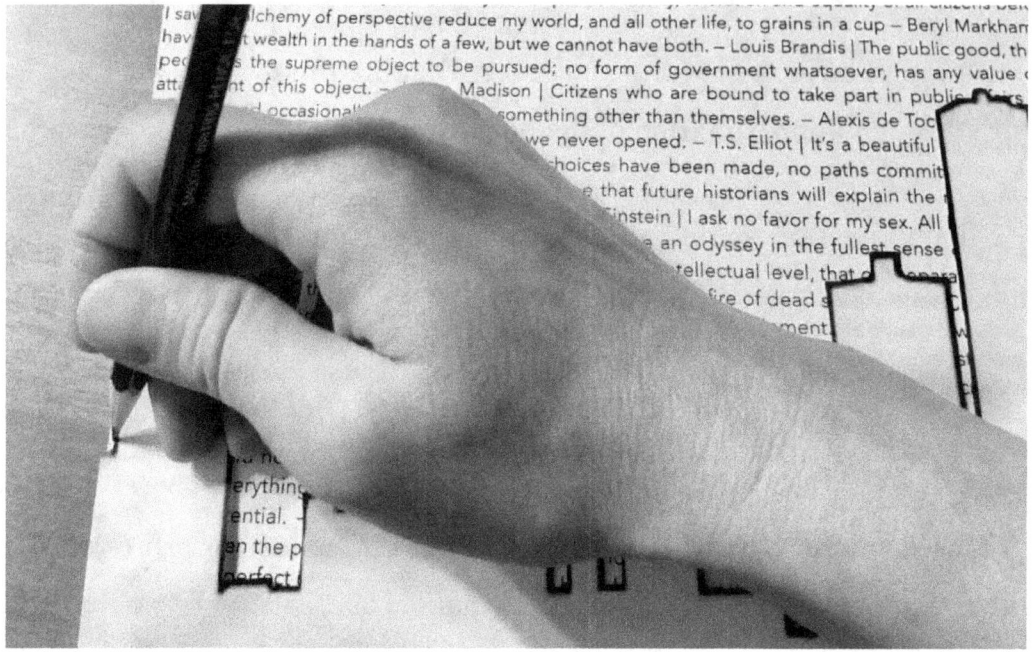

When you're happy with the size, trace the silhouette on to the card stock.

If possible, trace on to the back side of the card stock.

If not possible, bear in mind that once you trace it, your final text silhouette will be slightly smaller than your cut line, since you'll need to cut inside of it.

Step 4: Cut

Using a precision craft knife or a pair of scissors, cut along the traced line.

When your silhouette is completely cut, even out the cut lines and remove any loose slivers of paper still attached to the silhouette.

Step 5: Attach the Silhouette to the Mat

Attach the text silhouette to the bottom layer of mat board so that it rests between the first and second layers.

Using craft bond or a similar adhesive, glue the silhouette so that's it is flush against the edge of the top layer of mat board.

 The image should appear to be coming from in between the two layers of mat board.

Once glued, set aside to allow time to dry.

Step 6: Prep the Accents

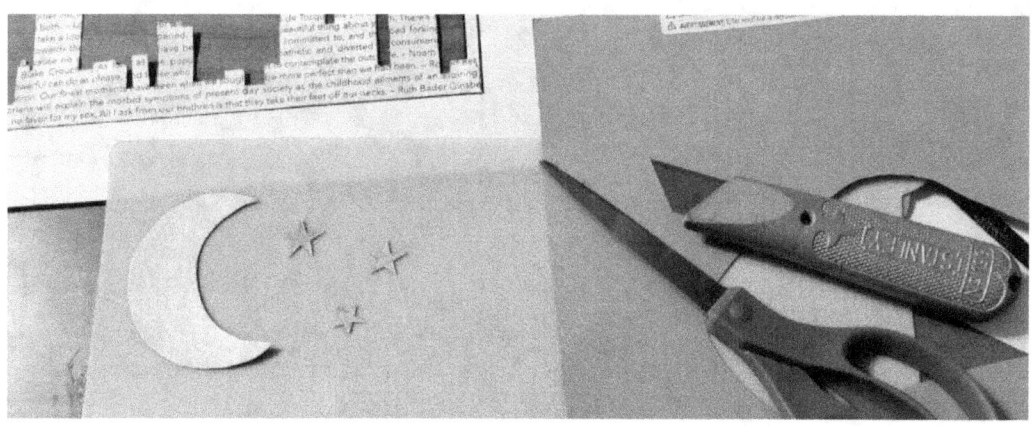

The color accent adds a vibrant focal point to the image. The color and shape of the accent will depend on the type of silhouette you made.

In the sample at the start of the chapter, two red card stock hearts hang from a branch but two colorful bird silhouettes would have worked just as well.

It all depends on what you like, where you plan on hanging the final piece, or who you plan on giving it to.

 Think of any accent shape and color. It could be simple circles or squares to more complex shapes like birds and flowers.

In the sample above, I opted for gold card stock in the shapes of a moon and stars. Once you know the shape of the accents you want, sketch or trace the shapes on the colored card stock paper and cut them out.

Step 7: Glue Thread to the Accent Shapes

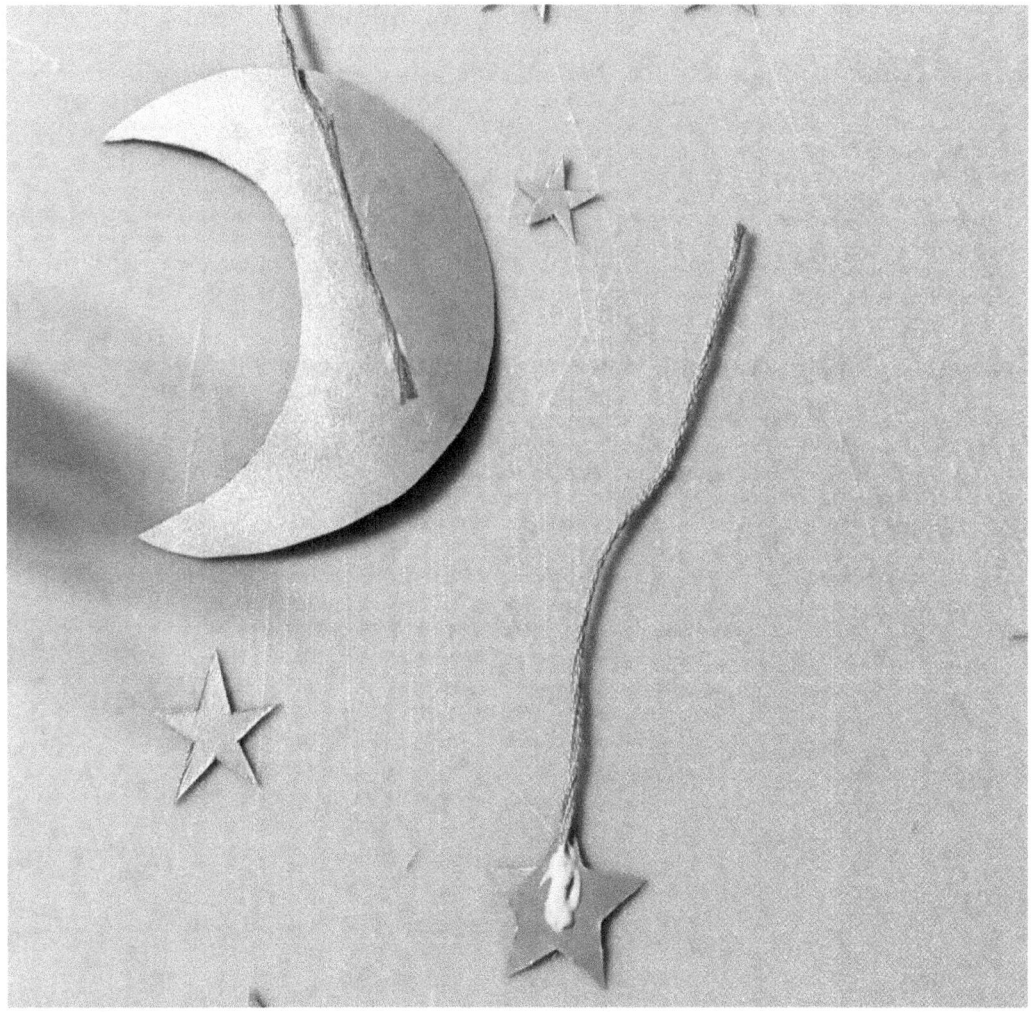

After trimming any rough edges off the accent shape, set the accent aside and cut a piece of embroidery thread to attach to its backside.

 The length of the thread doesn't have to be exact. It's better to estimate a little more than you'll need rather than a little less.

When a piece of embroidery thread, or a thread of a similar thickness, is cut for each accent you plan to include, lay out the accent pieces backside up.

Place the end of a piece of thread in the middle of each accent and attach with a thick dab of craft bond or a similar adhesive and set aside to dry.

Step 8: Attach Thread to the Mat

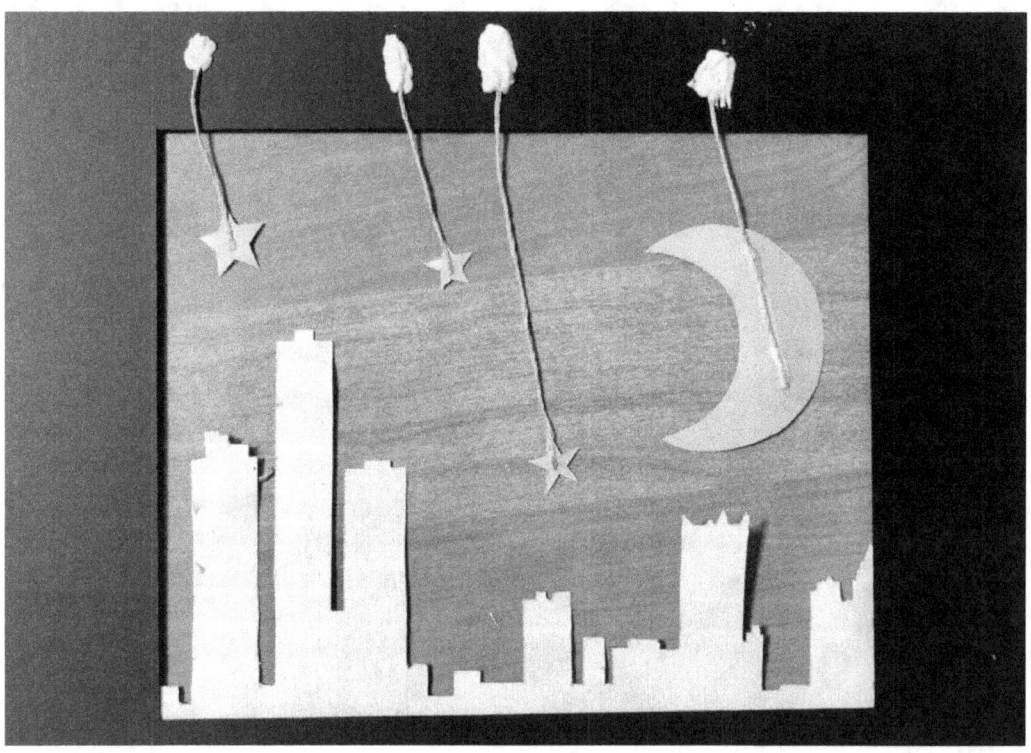

Once the glue is completely dry on the back of the accent shapes, hold the unglued side to the area you wish to display it.

If you plan on tying it around a tree branch, create a loose loop to make sure there is enough to tie.

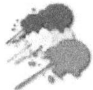 **Be sure that the accent shape does not touch the lower edge of the mat.**

If, like in the sample above, you plan on hanging it from the top of the mat, raise and lower the thread to get an idea of where you want it to hang.

Trim off any thread that extends farther than the middle of the top half of the mat board.

Flip the mat board upside down.

Attach the thread to the rear of the mat by using a thick dab of adhesive.

Make sure to straighten out the thread so that the front side of the accent is visible from the front of the mat board.

Attach all accents and set aside to dry if a glue-like adhesive is used.

Step 9: Put the Mat in the Frame

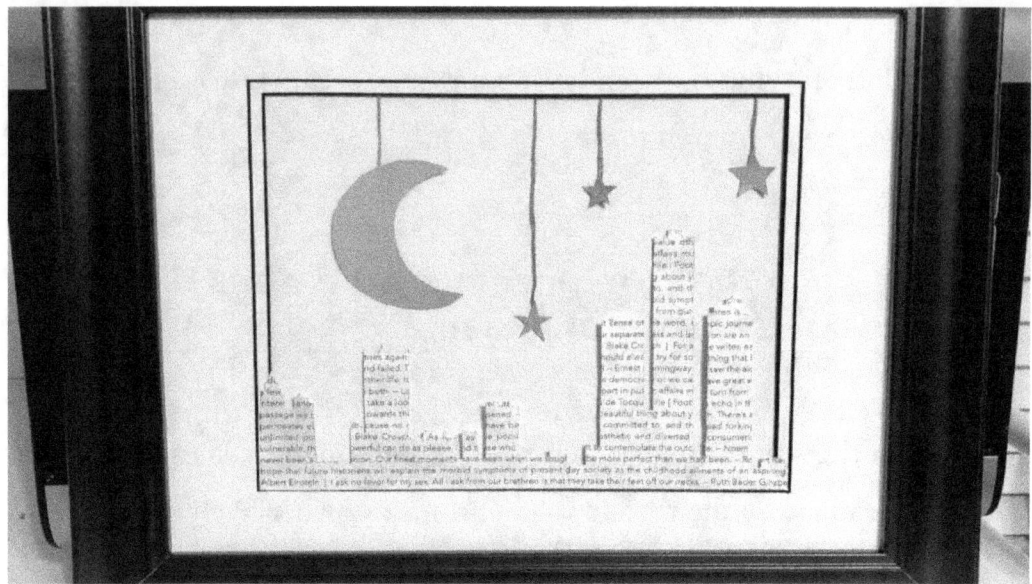

When all adhesive that was used is dry to the touch, carefully place the mat into the frame.

Melted Crayon Art

Skill Level: Intermediate

This art project is better suited for mature teens and adults.

Supplies

- Rectangular Canvas

- Unbroken Crayons

- Scrap Paper

- Precision Knife or Box Cutter

- Hot Glue Gun w/Sticks (or heavy duty glue of choice)

- Paper Plate or Bowl

- Scissors

- Non-Permanent Glue or Tape

- Blow Dryer

- Grill Lighter

- Black Paint

- Pencil

- Black Paint Marker

- Stencil or Printed Silhouette

Preparation

This style of melted crayon art can get a bit messy and it involves the use of multiple types of heat to melt the crayons.

Before you start, make sure to cover your work surface and surrounding walls. Depending on the flooring type and size of your work area, you may want to consider covering the floors below your work area as well.

Steps

To control the wax drip, it's helpful to do this project in a location where you are able to lean your canvas against a wall.

Step 1: Picking the Crayons

Select the crayons you want to use and order them how they will be arranged on the canvas.

For this project, I opted to go for a full spectrum of colors, but any color scheme will work.

Use a piece of scrap paper to get a better idea of how each color should be arranged in the order you want them on the canvas

Once they are in order, use a precision knife to slice through the paper wrapper around each crayon.

Step 2: Remove the Wrappers

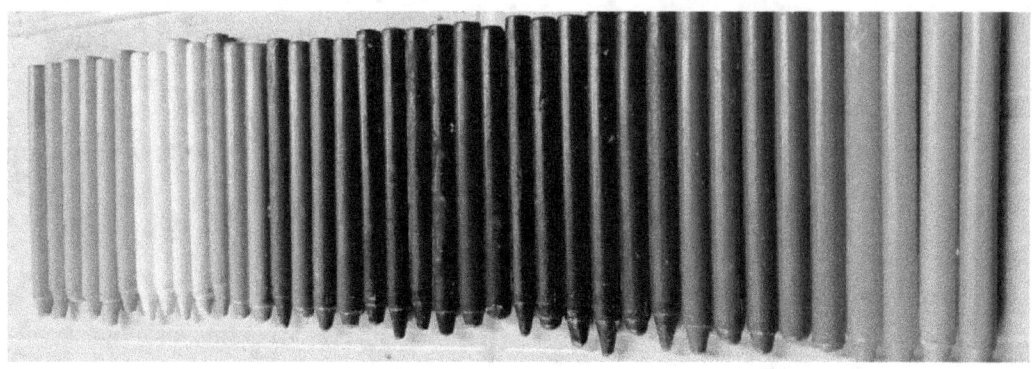

Remove and discard the wrappers, while keeping the crayons in order.

 Consider working in an area where your pieces won't be disturbed.

If you're doing this project in a shared workspace, make sure to secure your crayons in the correct order with a piece of masking tape.

Step 3: Prepping the Canvas

For this next step, we will attach half a paper bowl or plate to the bottom of the canvas to prevent wax splatter and drips from getting on that part of the canvas.

 Bowls tend to work better for smaller canvases, but the choice is yours.

The sample image shows a paper plate on an 11" by 18" canvas.

The thing to consider when deciding the size and shape of the area covered is that the image will eventually be there.

As shown in the sample picture at the start of the chapter, I did a silhouette of a girl and a corgi under an umbrella.

I didn't think a bowl would offer enough room.

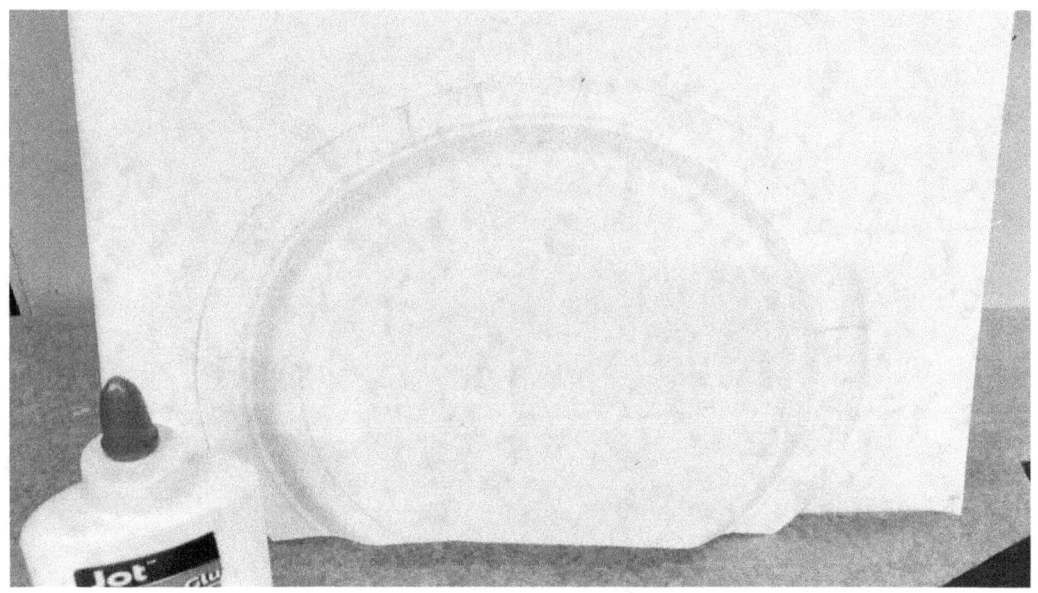

Once you know the size you need, cut off the bottom fourth of your plate or bowl so that it can be aligned with the bottom of the canvas.

Hold the bowl up to the bottom of the canvas and, if needed, straighten your cut line. Then, using a temporary adhesive, attach your

bowl to the canvas so that the bottom edge of the bowl lines up to the bottom edge of the canvas.

 Avoid any strong adhesives that might rip the canvas when removed later.

If you do not have temporary adhesive, use two-sided scotch tape or washable glue diluted with water.

Step 4: Attach Crayons

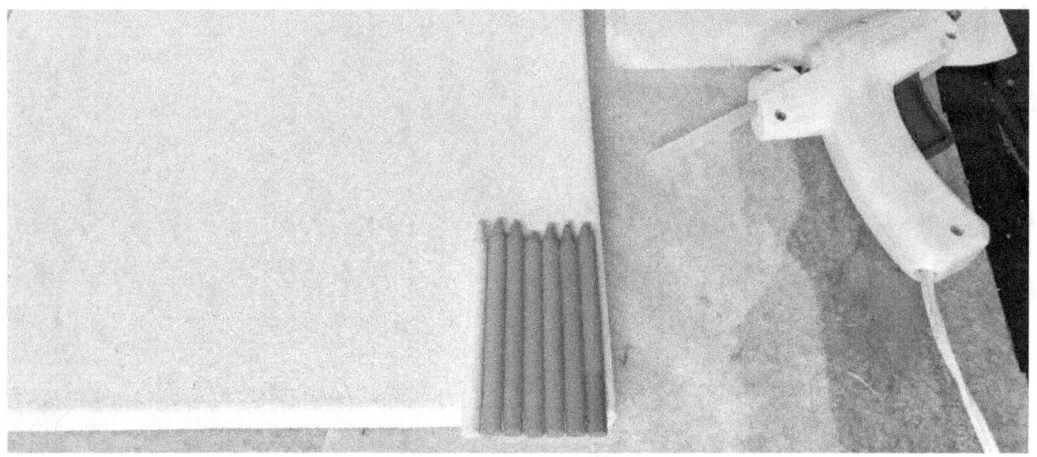

Using a glue gun or a strong, non-flammable adhesive, attach crayons to the top of the canvas with their pointed end facing down toward the bowl at the bottom of the canvas.

Allow time for the adhesive to dry if needed.

Step 5: Determine the Angle of the Canvas

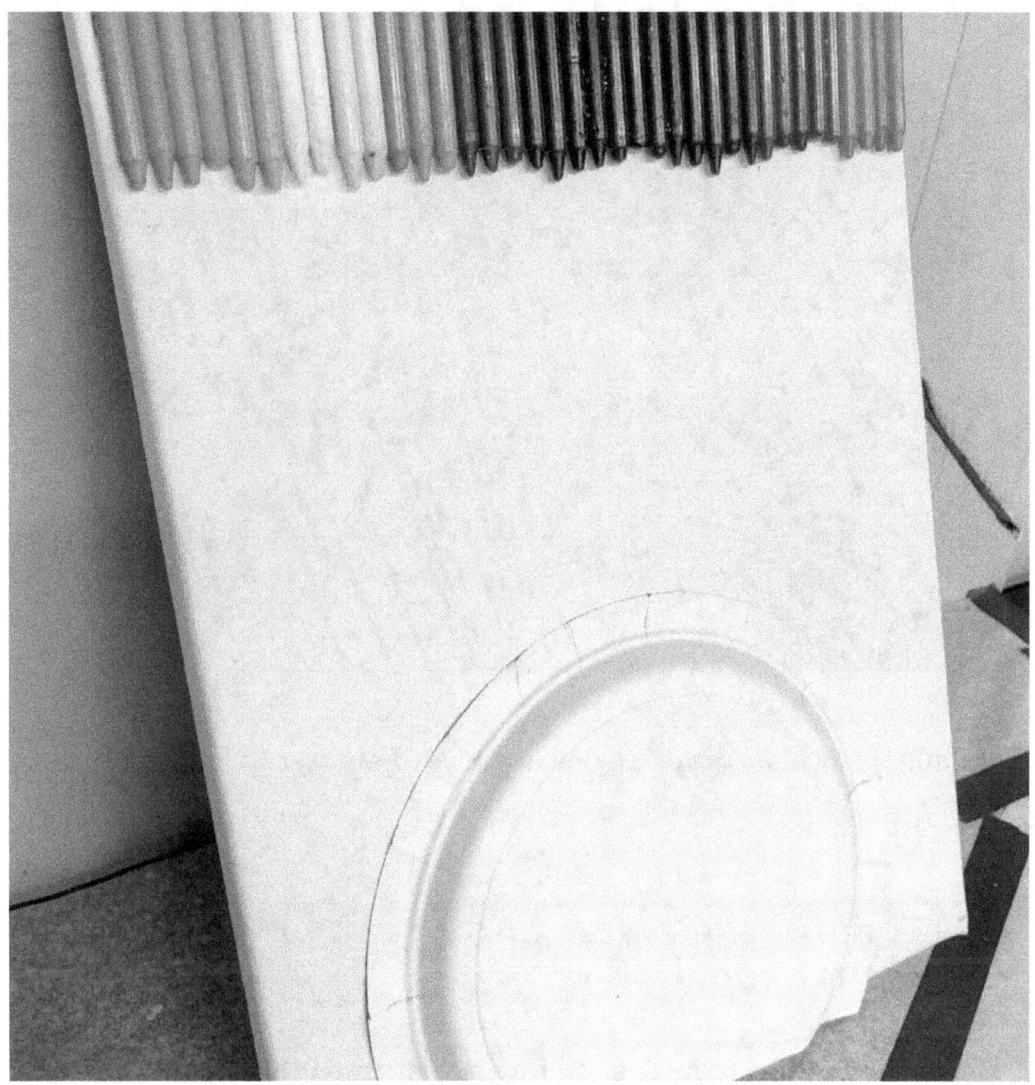

When all of the crayons are securely attached to the top of your canvas, prop it up against the wall. Situate it so that it is slanted with the top edge against the wall and the bottom edge resting on the table about 2 to 4 inches away from the wall.

Step 6: Melt the Crayons with a Blow Dryer

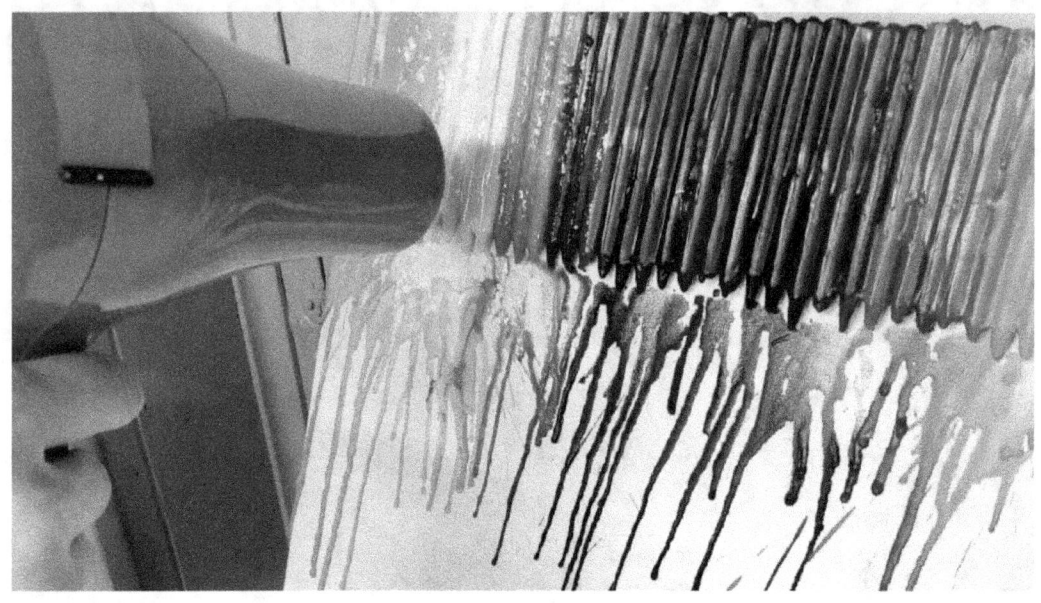

Holding your blow dryer angled downward and set to low, apply heat to the crayons.

 It may take about thirty seconds to get the melt going.

Hold the dryer over the first 4 or 5 crayons until the wax begins to run. Move to the next section of crayons, swiping back and forth over previous sections to keep the first crayons soft.

Once all crayons are running wax, continue applying heat from a few inches away from the canvas until the entire background of your canvas is lightly coated in color.

Set the canvas aside and allow the crayons to dry and return to a completely solid state.

Step 7: Melt the Crayons with a Lighter

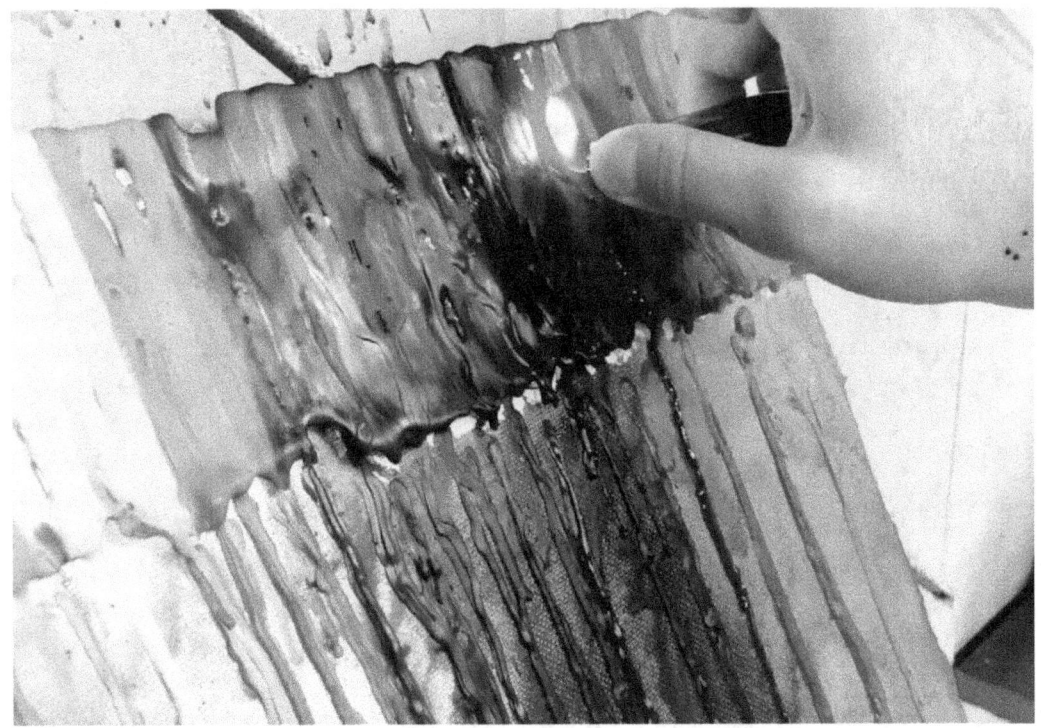

In step 6, we used a blow dryer to color the background of the canvas.

For thick drips of colorful wax, a more precise and intense heat source is needed.

Grill lighters work best for this part, but if one is not available, you can substitute four or more regular lighters, long-stick matches, or a similar heat source.

Regular lighters quickly become hot and can burn your skin.

 If you'll be using a small cigarette-type lighter, avoid using the same one twice or for longer than ten seconds.

Apply heat to the first crayon.

Move the flame up and down the length of the crayon until drips of wax form and flow from the tip of the crayon to the desired length on the canvas.

Skipping three crayons, apply the flame to the fourth crayon over.

Once the wax drips flow to the desired area of the canvas, skip three crayons and move on to the eighth crayon. Follow the same directions.

Repeat this process until you reach the end of the canvas.

When you reach the end, go back to the second crayon. Repeat the process again starting from the second crayon, skipping three crayons in between each drip.

When you reach the end of the canvas, repeat this process one final time.

Begin with the third crayon until there are colorful drips of wax from each crayon.

Skipping three crayons between melted crayons enables more control over drip lines by preventing wax flows from nearby crayons to merge together.

Step 8: Allow to Dry

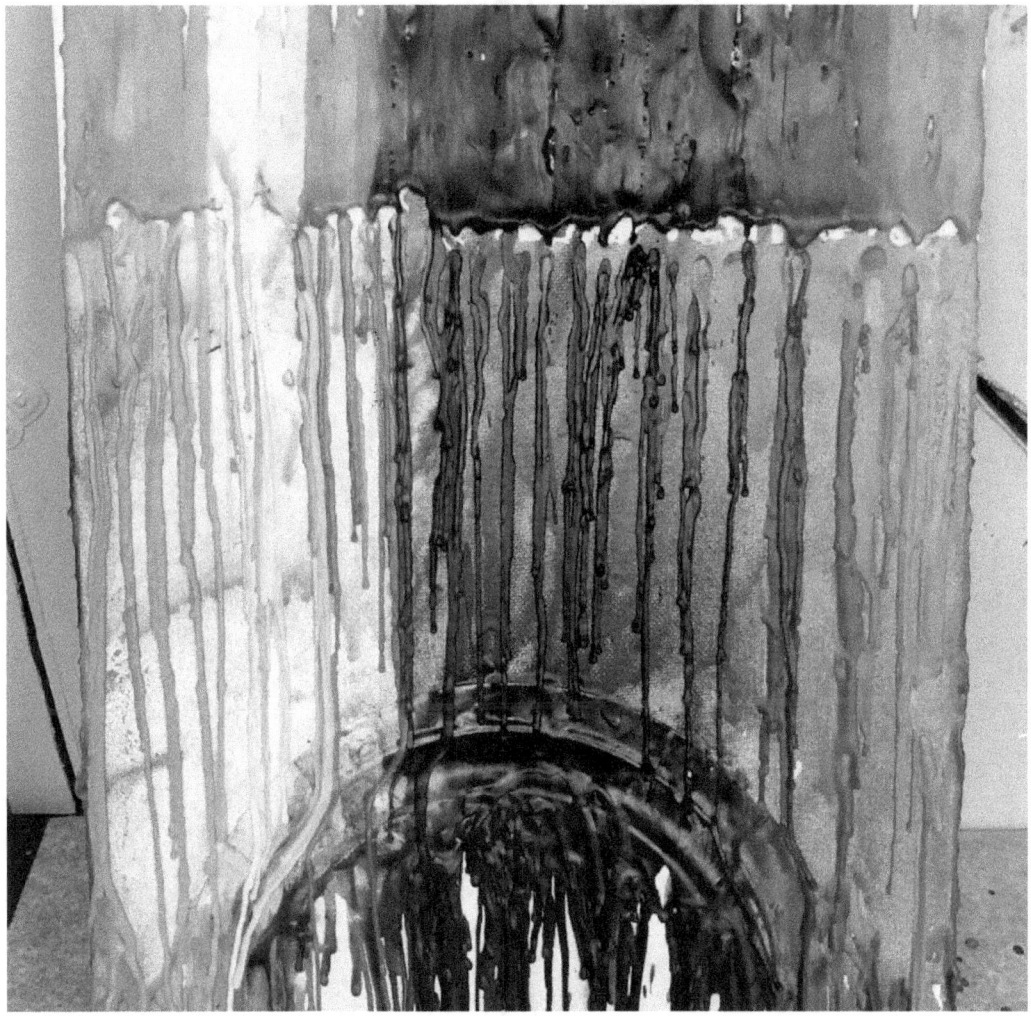

Keep your canvas propped against the wall.

Allow time for the drips to dry and the crayons to return to a solid state before moving forward.

Step 9: Remove the Bowl or Plate

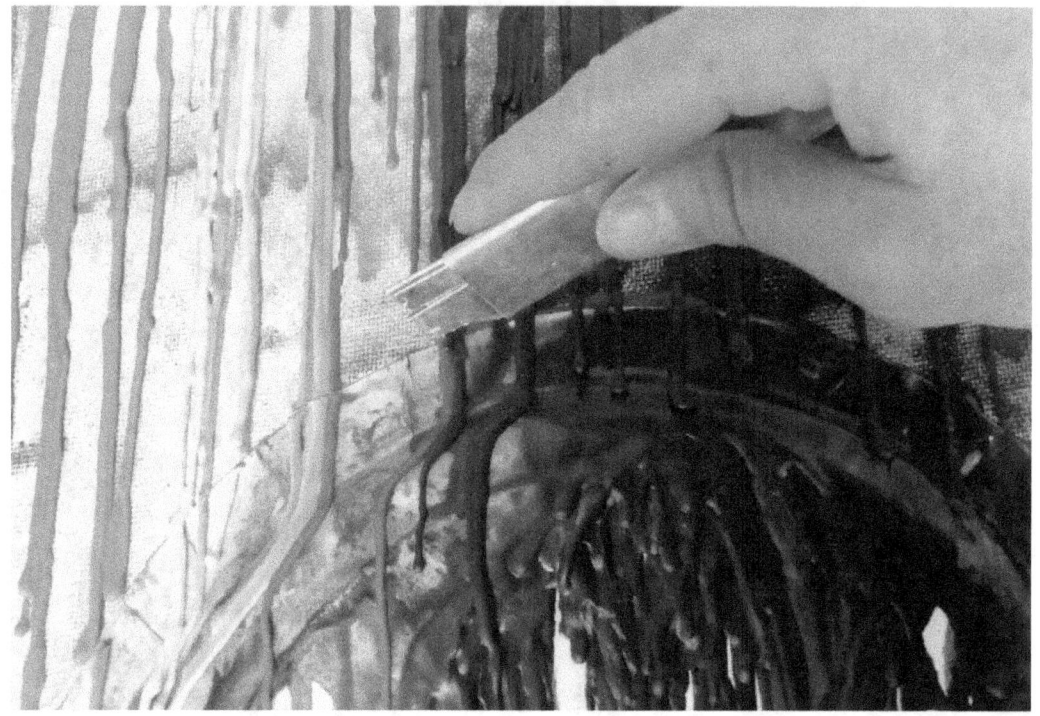

Once the wax is completely dry, use a craft knife or box cutter to cut through any hard wax along the edge of your plate or bowl.

 Be careful to not cut through the canvas. Don't press too hard with your cutting instrument!

Next, remove the plate from the canvas. Check the canvas for left behind tape or glue and carefully remove any remnants of adhesive.

Step 10: Prep the Silhouette

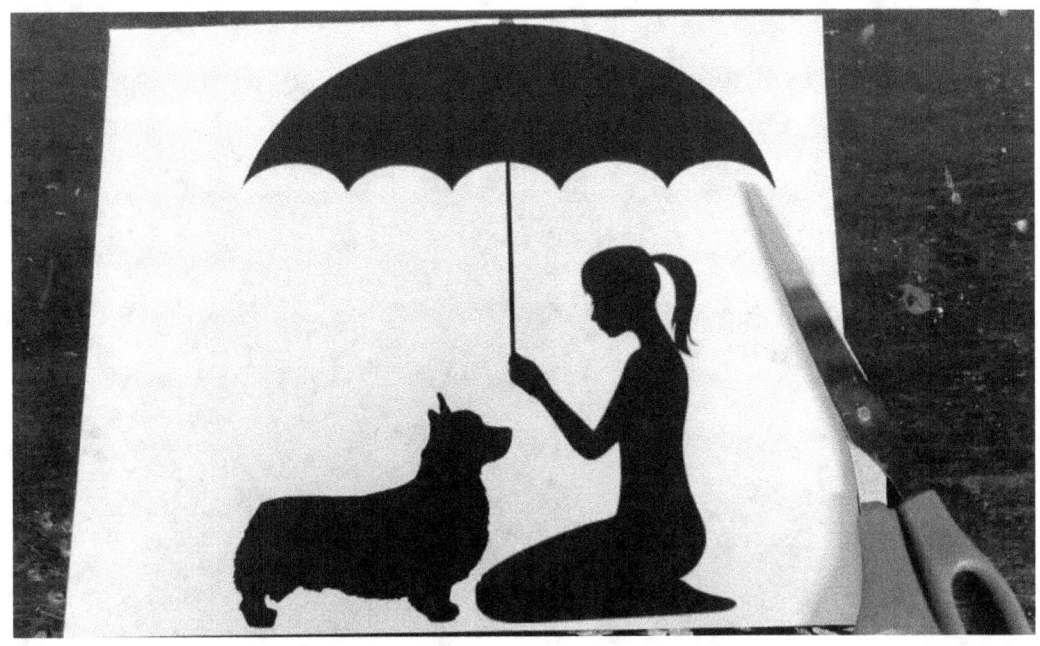

If you are using a stencil or plan to sketch your design, skip this step and move on to step 11 or 12.

 The step you skip to depends on your level of painting experience.

If you printed a silhouette, cut it out so that it can be used as a stencil and traced onto the canvas.

Step 11: Trace the Silhouette

Lightly trace your silhouette onto the canvas using a pencil.

 Your image doesn't have to be a silhouette but you may want to consider using a contrasting color image.

The black and white in the example contrast nicely with the colorful crayon wax.

Step 12: Outline the Silhouette

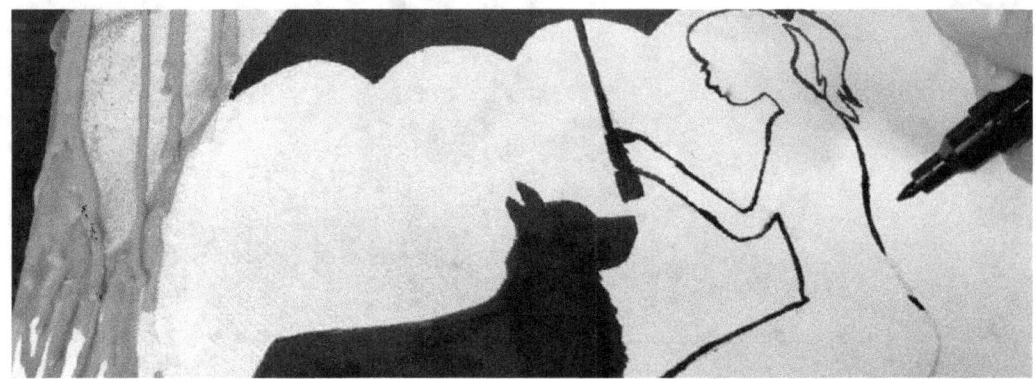

Using a thin-tipped detailing paint brush and black paint (or a thin-tipped black paint marker), outline the silhouette.

Step 13: Paint the Silhouette

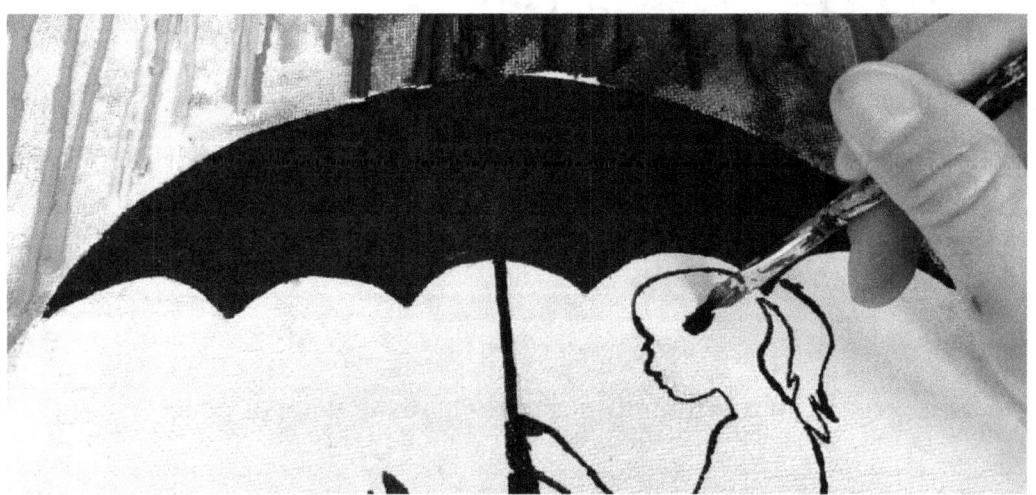

Use black paint to paint the interior of your silhouette. Allow at least 15 to 20 minutes to dry before applying the second coat of paint. Depending on the type of paint you used, a third coat may also be necessary. When finished, allow the paint to fully dry before hanging.

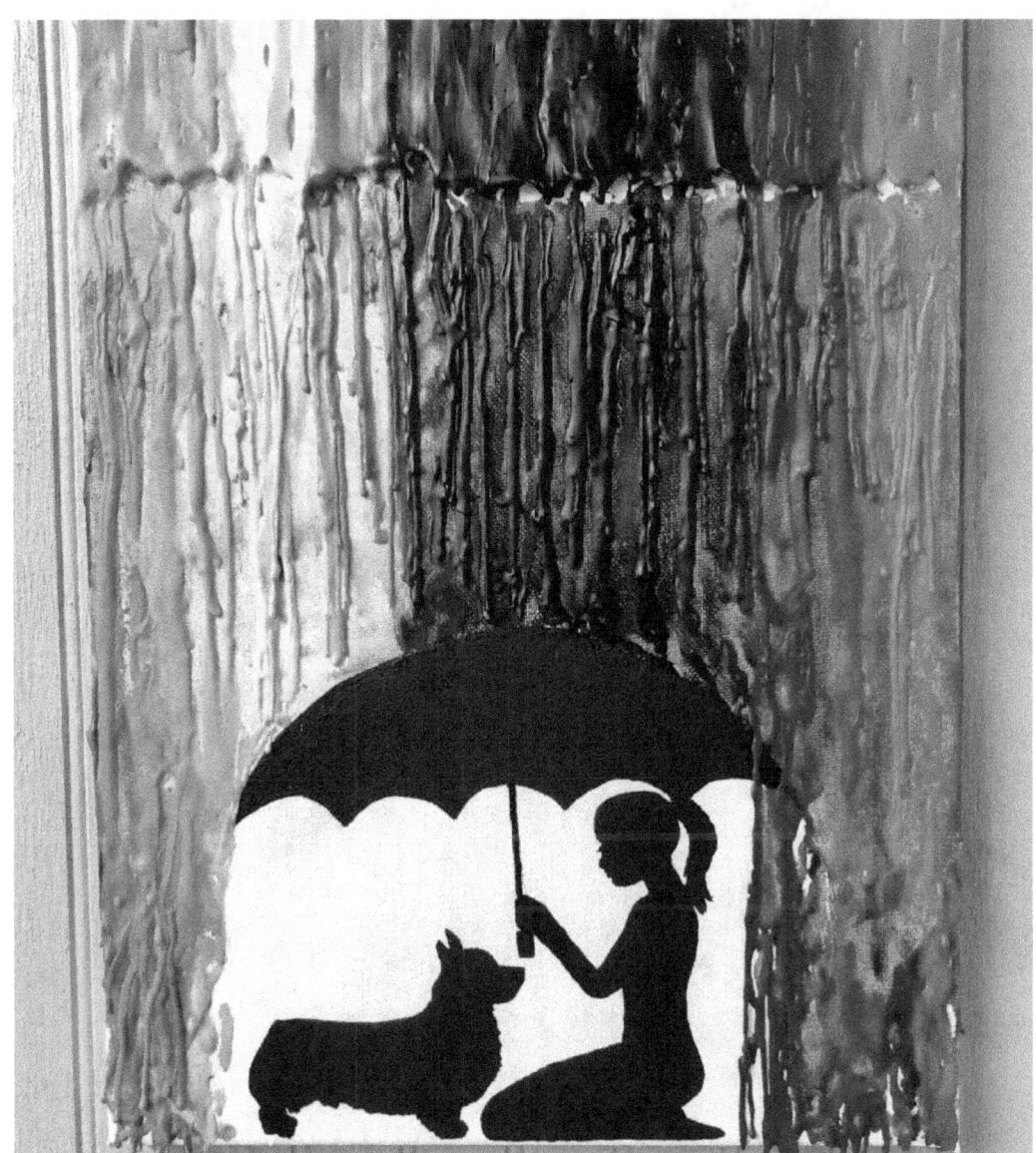

Colorful Wax Painting

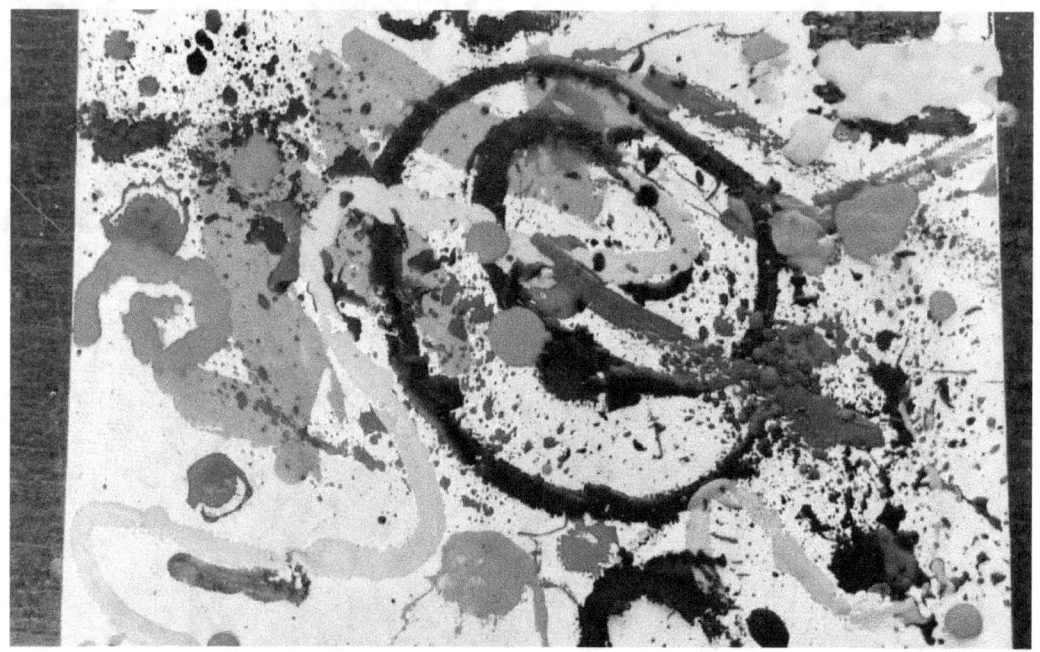

Skill Level: Easy

This type of vibrant wall art is easy to make, doesn't require much time or skill and is a great way to use old crayons.

This is a fun project for adults and children alike, however, adult supervision is recommended to prevent burns or messes from melted crayon wax.

Supplies

- Canvas (shape and size of choice)
- Disposable Muffin Pan
- Cheap Paint Brushes
- Old Crayons
- Oven Mitt
- Eyedropper

Preparation

Set your oven to 275 degrees (Fahrenheit).

Cover your work surface with paper or parchment to catch any wax that spills.

Either use a disposable tray or a muffin tin dedicated to art projects.

Opt for cheap or old paint brushes that can be disposed of if needed.

Steps

The muffin pan you use for this project will no longer be safe for food after the crayons are melted in it.

Step 1: Peel Crayon Wrappers

While the oven is warming, peel the paper from the crayons. For this project, broken crayons are perfect but unbroken crayons work too.

Step 2: Break and Sort Crayons

Break crayons into 2 or 3 pieces.

Sort the crayon pieces into muffin trays sections by color family.

Step 3: Melt the Crayons

Place the muffin tray in the oven for about 15 minutes or until the wax is completely melted.

Step 4: Remove and Stir

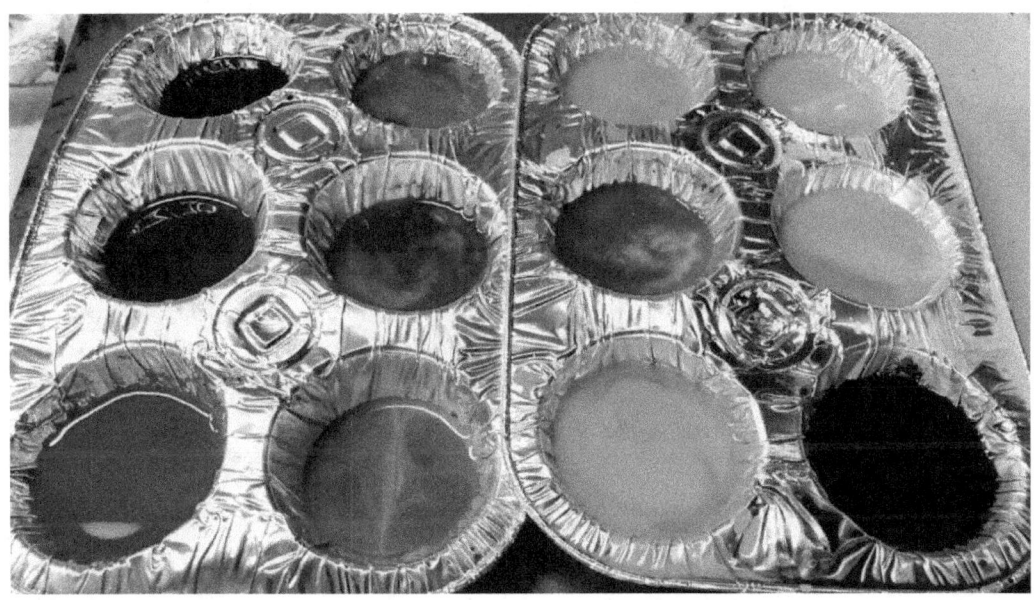

Wearing oven mitts, remove the muffin tray from the oven and bring it to the work area.

Stir the melted wax to mix each color family.

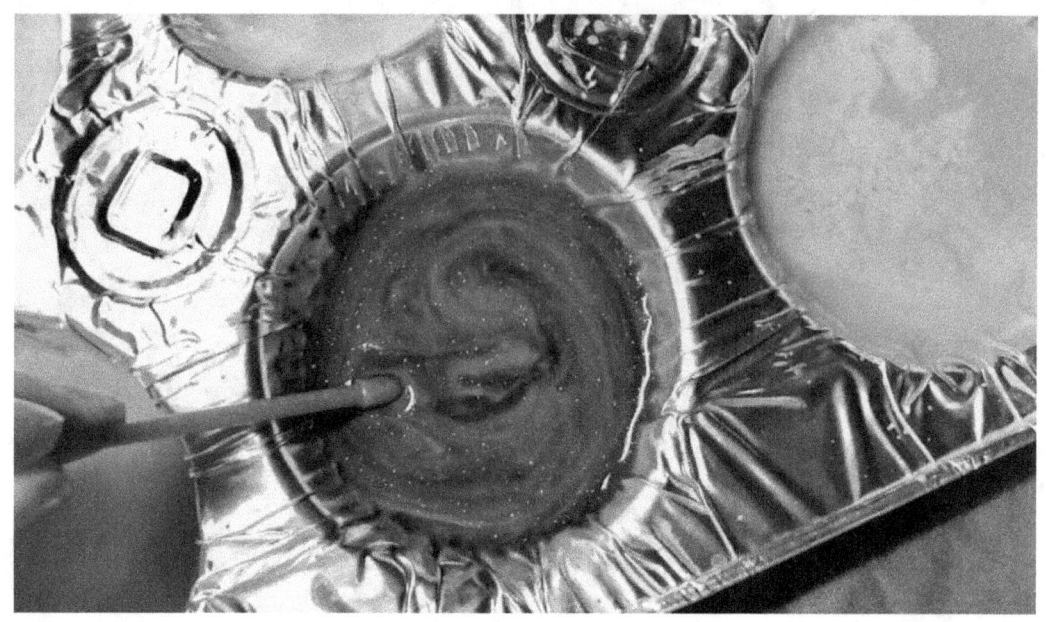

Step 5: Paint

Enjoy painting with brushes, making paint splotches with eye droppers, and splattering wax with plastic forks.

Wax paintings usually result in a piece that resembles contemporary art, but that doesn't mean it has to be completely random.

 You may want to keep the oven on to melt the wax again once it begins to solidify in the muffin pans.

Wax begins to cool immediately and returns to solid form in 10 to 25 minutes, depending on how quickly you use it.

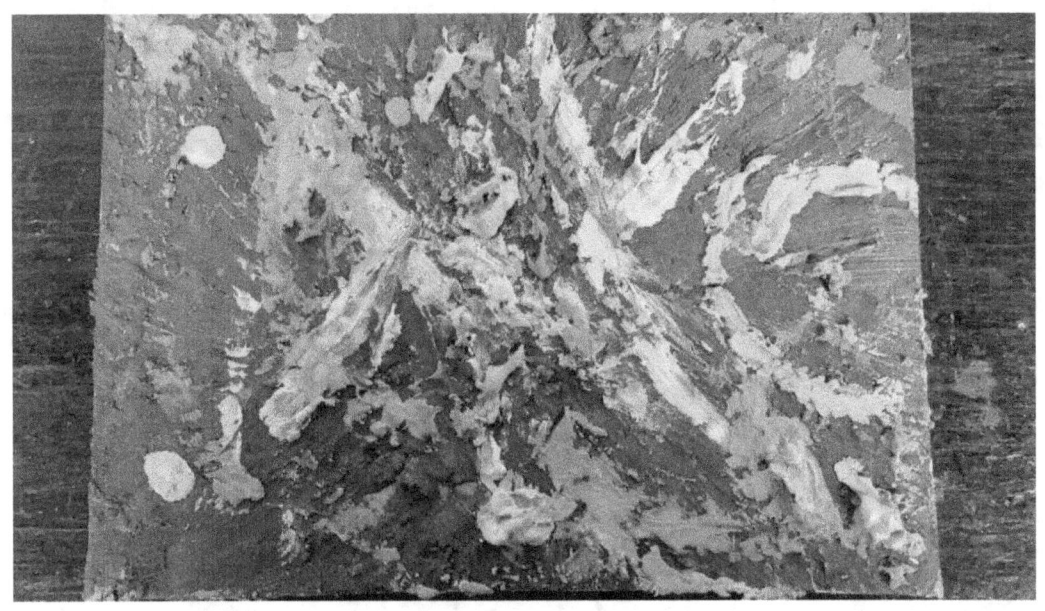

Create the image of your choice. This can become a wonderful conversation piece for guests to decipher and discuss.

Button Tree Painting

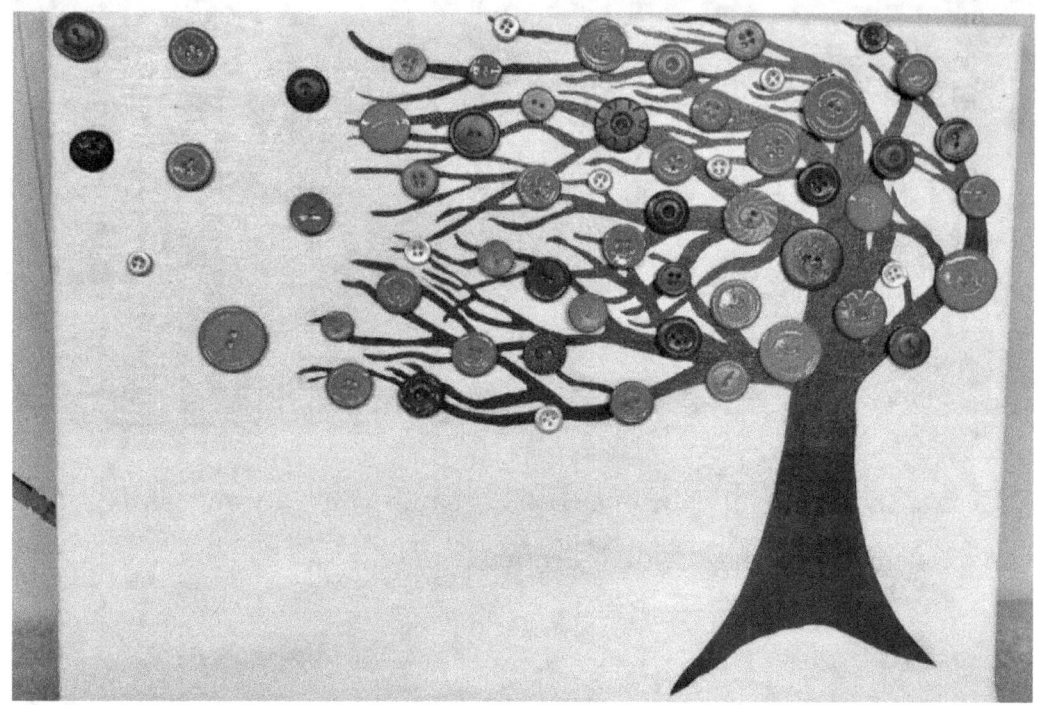

Skill Level: Easy

This colorful, three-dimensional wall art takes a little more time but isn't difficult. This piece is sure to brighten any dull space.

Supplies

- Rectangular Canvas

- Old Buttons

- Fine Grit Sanding Block

- Spray Paint

- Acrylic or Tempera Paint

- Glossy or Matt Top Coat

- Paint Brushes

- Foam Brushes

- Pencil

- Multi-Surface Adhesive

- Stencil or Cutout of a Wind-blown Tree

Preparation

For this project, you'll need an indoor work area and a temporary outdoor workspace for spray painting.

Steps

Sort through your stash of old buttons to look for any that have flat backs.

Step 1: Sorting and Cleaning Buttons

Once you have about 20 to 30 that can be used for this project, go through them to remove any lingering threads and check for damage.

Mix a dab of dish soap with warm water and do a quick clean of the buttons, then set them aside to dry.

Step 2: Sand and Rinse the Buttons

Once the buttons have dried, gently sand them with a fine grit sanding block.

After sanding each one, make sure to wipe or rinse each button to remove debris.

After sanding them, I placed a little bucket of water nearby and swished each button around for a few seconds then set it on a towel to dry.

> **Employ some time-saving, multi-tasking techniques anywhere you can in the process of making art!**

These were drying while I sanded the remaining buttons.

Then when finished sanding, I gave them a quick pat down to make sure they were totally dry.

Step 3: Spray Paint Buttons

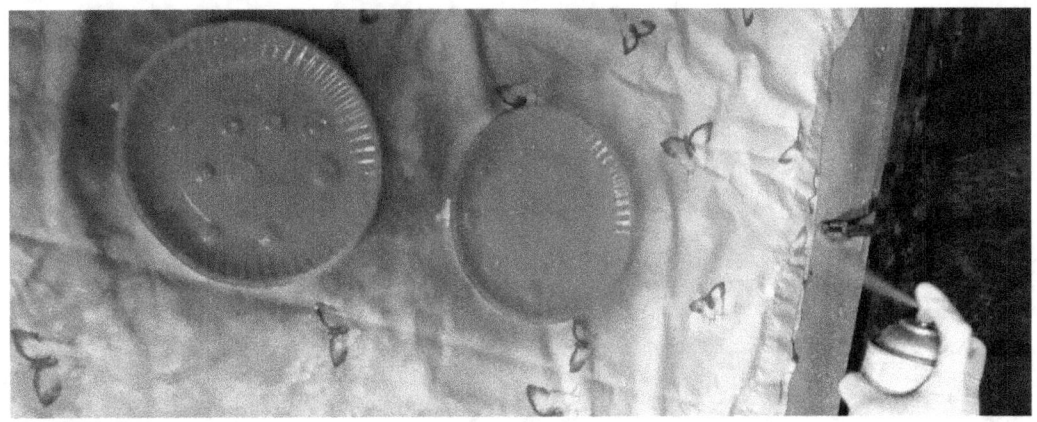

Once all your buttons are sanded, rinsed, and dried, bring them to your outdoor work area and apply a coat of spray paint.

For this project, the buttons are the leaves and can be painted in an assortment of colors or a single color.

 If you'll be using multiple colors, be mindful to leave a couple of feet of space between areas where different colors will be applied to prevent color mixing.

For the best coverage, hold the spray paint can about 12" inches away from the buttons and spray in a continuous sweeping motion.

After applying the first coat of spray paint, set the buttons aside to dry for at least an hour.

Step 4: Painting the Background

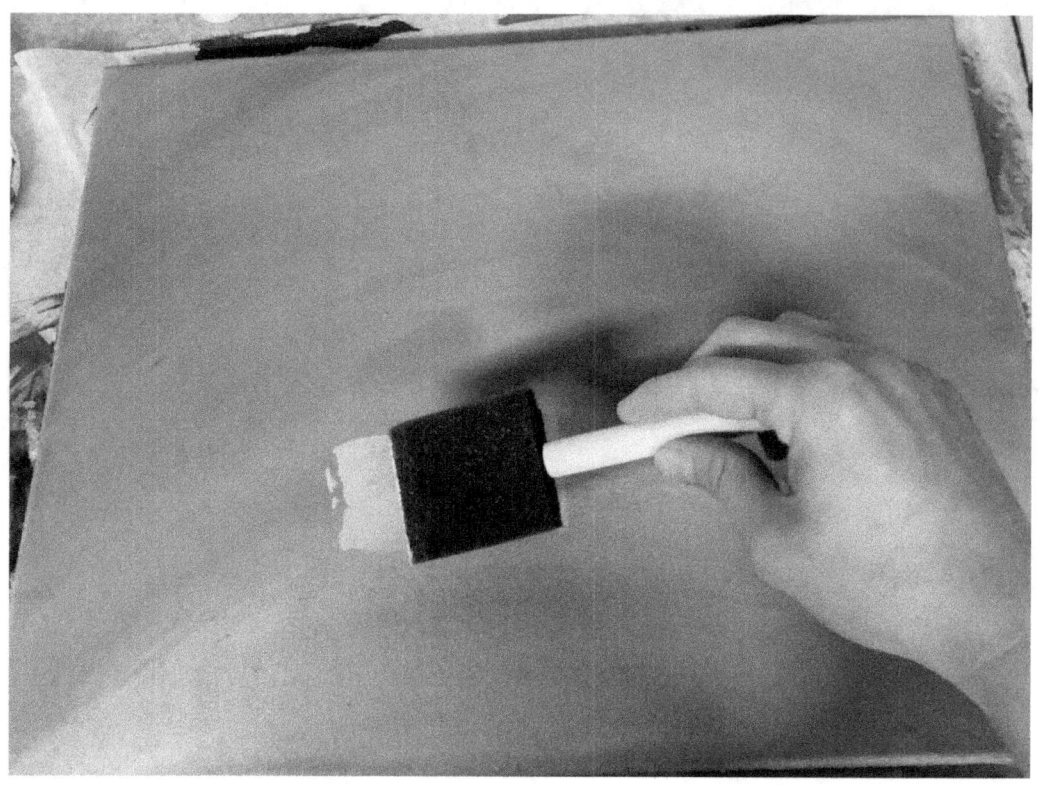

While the first coat of spray paint dries, return to your indoor work area to paint the background of your canvas. Use acrylic or tempera paints with bristle or foam paint brushes.

 The background can be a single color, a sunburst, multiple colors, landscape, or a specific design. It's up to you.

One of the great things about working with acrylics and other craft paints is the ability to paint over the canvas once the first coat is dry.

Have fun painting the background of your choice. If it doesn't come out to your liking, simply allow it to dry, then repaint it.

Step 5: Top and Second Coats

While your canvas dries, return to your outdoor workspace and apply a second coat of spray paint to your buttons.

If possible, spray them from multiple angles to ensure good coverage. When finished, return to the indoors workspace.

If the background is to your liking, apply a top coat to brighten the colors and add a thin layer of protection to the canvas.

Once the top coat has been added, set the canvas aside to dry and find a secure place for the buttons to dry.

Depending on the type of spray paint used, you may be able to bring them back inside.

 Some spray paints remain odorous until completely dry.

Allow the buttons and the canvas to dry completely, overnight if possible. They should dry for a minimum of 10 to 12 hours.

Step 6: Sketch Your Tree

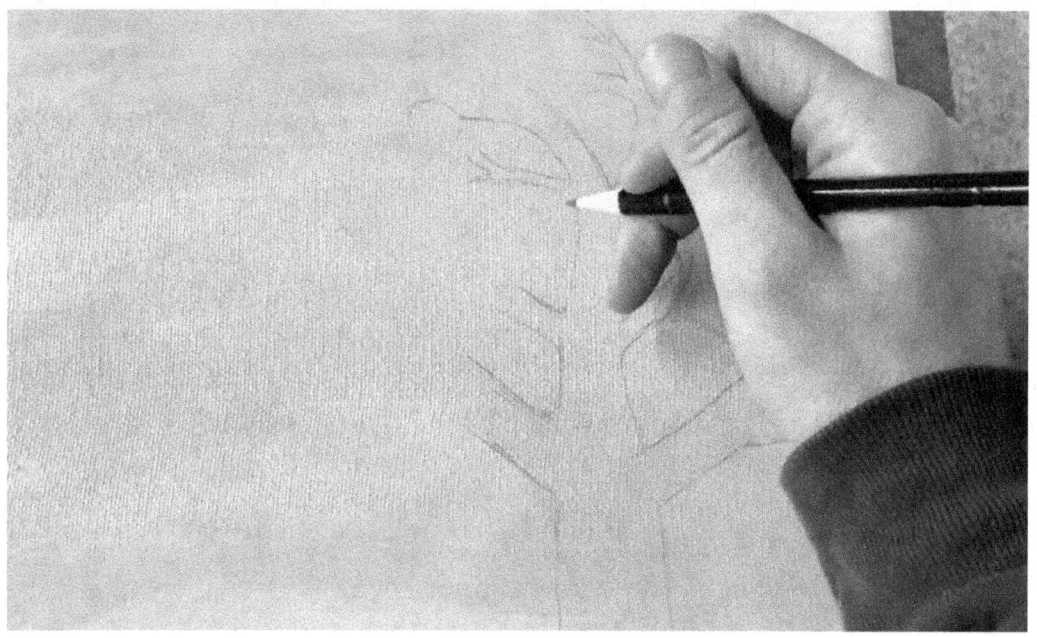

Using a pencil, lightly sketch a tree trunk with outstretched limbs on your canvas.

For this project, the tree has a wind-blown appearance so it doesn't have to be perfect.

 If you are uncomfortable drawing the tree on your own, you can always trace it.

To trace the tree use a stencil, do an internet search for tree silhouette or windblown tree silhouette. Download and print the image of your choice. Cut it out and trace it on to the canvas.

For a more detailed look at how this is done, check out Step 2 of the "Bottle Bottom Tree" instructions in chapter one.

Step 7: Paint the Tree

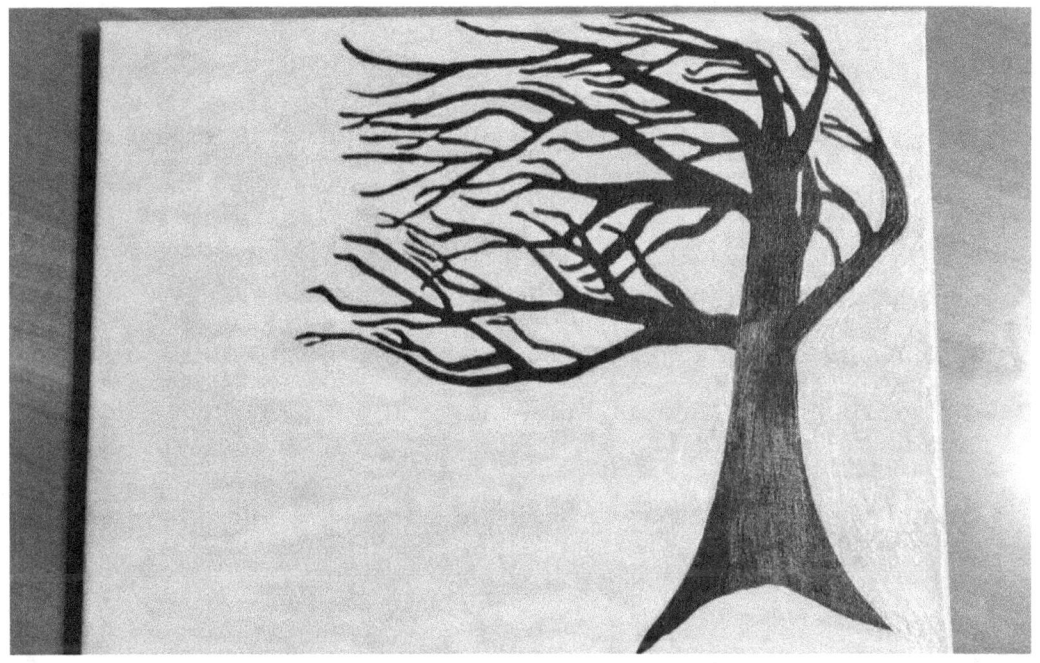

Use brown acrylic or craft paint to paint the tree. I opted for a rich brown color, but any color will work.

If using craft paint, two coats may be necessary. For the tree branches, use a fine-tipped detail brush.

 Using your best thin brush, lightly swirl the tip of the bristles in a circular motion in the paint.

This technique makes it easier to paint detail and stay inside the lines.

However, if some of your paint goes outside of the lines, don't worry about it. As long as the traced outline isn't dark or indented into the canvas, you should be able to erase it without affecting the background color or design.

If you are unable to erase part of a line or made a mistake elsewhere, there are a couple of ways to fix it without starting anew.

If the error is small and in an apt location, it may be able to be covered by a button leaf. If it can't be covered by a button leaf, allow the tree to dry completely then touch up the background where needed.

Depending on the color of the background and the color of the tree trunk, multiple coats may be required.

Step 8: Gather Buttons and Do Touch-ups

When you have finished painting your tree, set your canvas aside to dry and retrieve your painted buttons.

Look over your buttons to make sure the top and sides are fully covered and that paint hasn't covered over the holes.

> **Simply poke a needle through the button holes to remove the paint build-up.**

Now is the time to make sure you have enough buttons to cover the width of the canvas and, at the very least, enough to dot the tree branches.

It's okay if you have too many, this will give you options for placement. If you aren't sure if you have enough, now is the time to prepare more and make any needed touch-ups to previously painted buttons.

Step 9: Organize the Buttons on the Tree

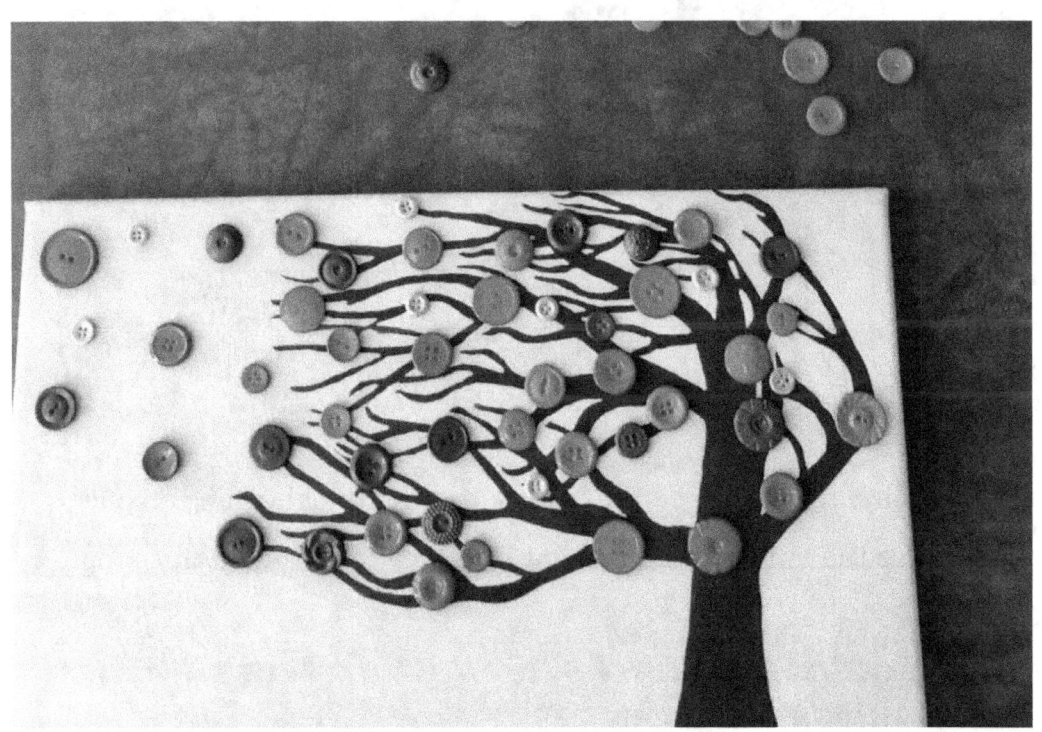

Play around with the buttons on your canvas to figure out where you want them to go. Make sure to lay out all the buttons you plan to use exactly how you want them on the canvas.

By waiting to glue until after you've laid out all the buttons, you have the opportunity to move them around. Notice areas that have too much or too little of a certain color or style and beware of noticeable bare spots.

Step 10: Glue the Buttons

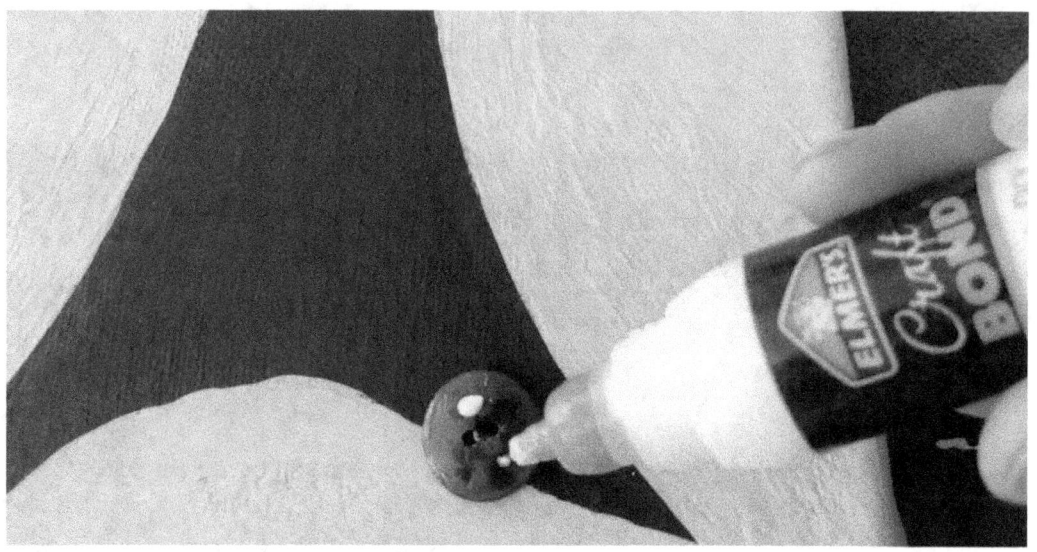

Once you have composed the layout, begin gluing buttons on one at a time. Leave the button arrangement in place while you do this step.

 I found it is easier to start on one side and work my way across.

Multi-surface adhesive, craft bond, or a hot glue gun work best on canvas. I prefer using a craft bonding agent as they tend to dry clear and quick and don't leave a mess.

Once you've glued all the buttons, allow time for the project to dry.

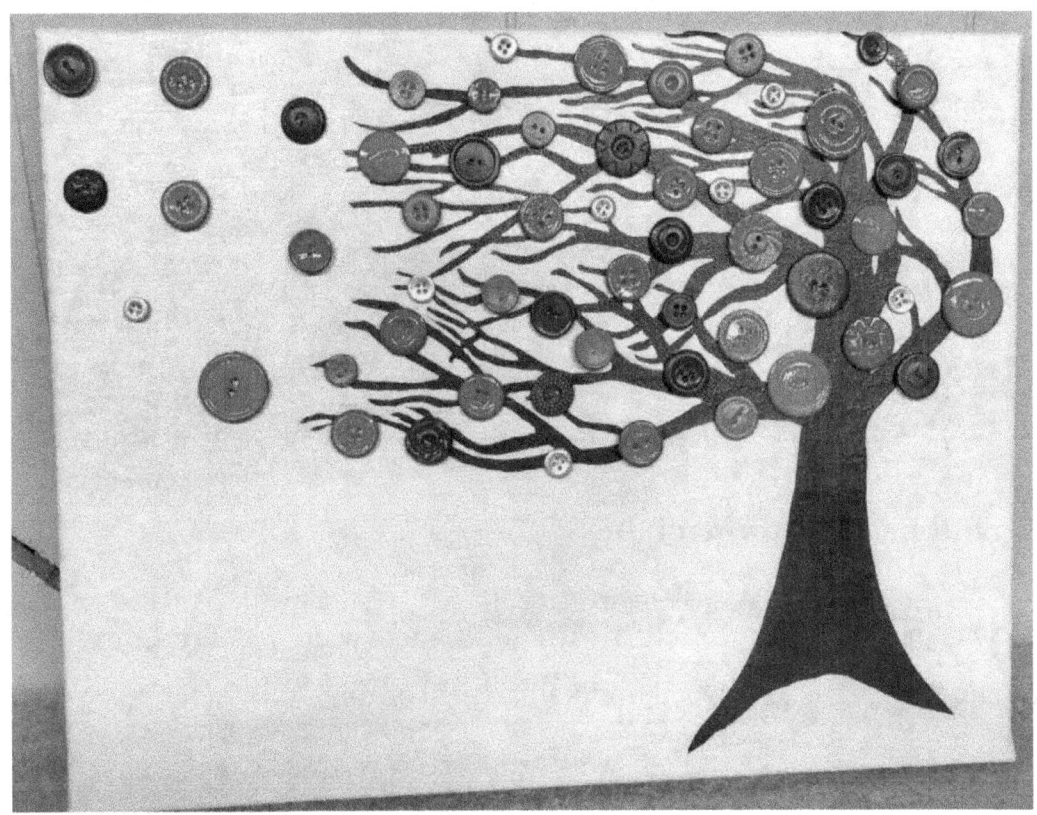

Nail Yarn Art

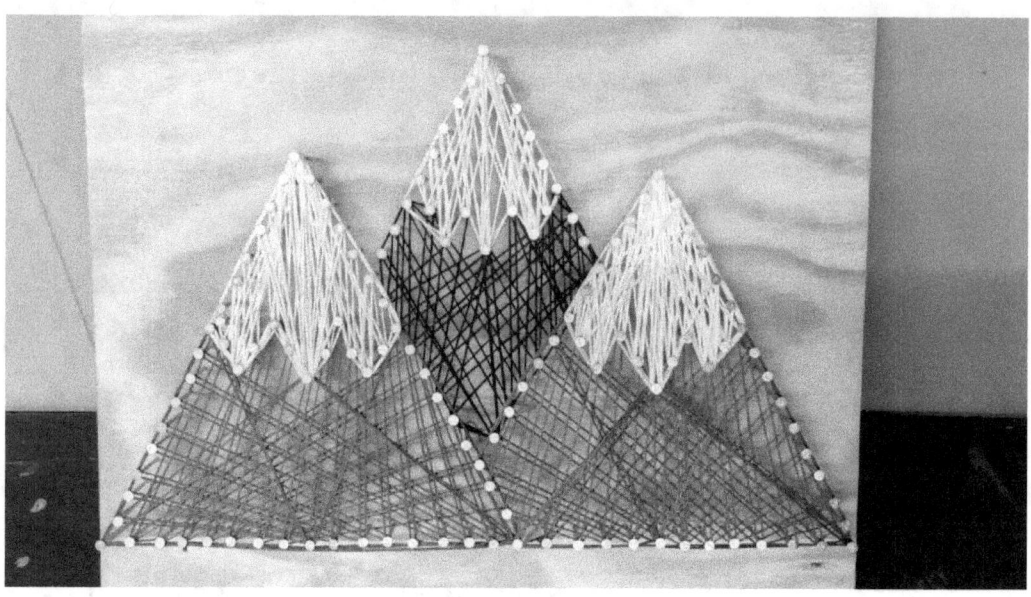

Skill Level: Intermediate

This project is best handled with adult supervision, as it requires hammering nails into wood and using wood stains.

Supplies

- Wood

- Nails

- Hammer

- Embroidery Yarn

- Pencil

- Sanding Block

- Wood Stain

- Stencil or Printout of Design

Preparation

For this project, you'll need a piece of wood that's at least a half-inch thick with a surface area large enough to display your image of choice.

Softer woods like white pine, hemlock, chestnut, and poplar are good options for this project.

Any wood will work, however, if you use a thin piece of balsa wood, it's easier to accidentally nail all the way through and require the use of shorter nails.

 It may be more difficult to place nails in harder woods like hickory, birch, and white oak.

Much of this project can be completed indoors, but an outdoor workspace or a very well ventilated indoor work area is needed for sawing, staining, and sanding.

Steps

Open windows and fans may not provide enough ventilation to prevent the inhalation of the dangerous vapors from using polyurethanes and stains.

Step 1: Cut Wood

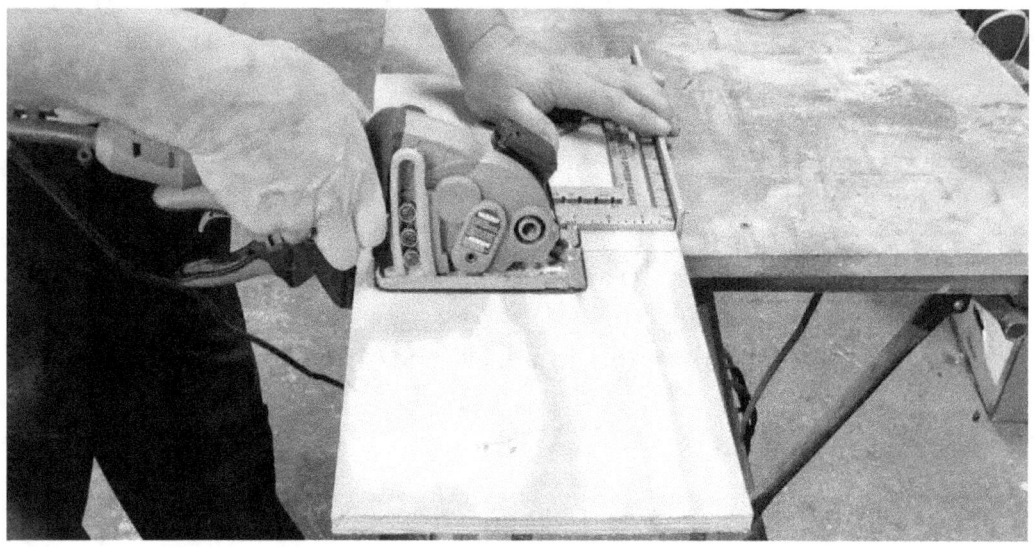

Once you have selected your wood, cut it down to the correct size using a circular saw, jig saw, or miter saw. Many hardware stores are able to assist with cutting wood.

 For this project, I used wood left over from a construction project.

My piece of wood was about seven-and-a-half inches wide. I cut it to a length of 10 inches.

If you do not have access to a power saw and plan to purchase your wood from a hardware store, know the size of wood you need in advance.

Ask the store if they have any leftover wood in that size or if they are able to cut a piece of wood to your desired size.

Alternatively, if you are experienced with using power saws, many hardware stores also rent power tools.

Step 2: Sand the Wood

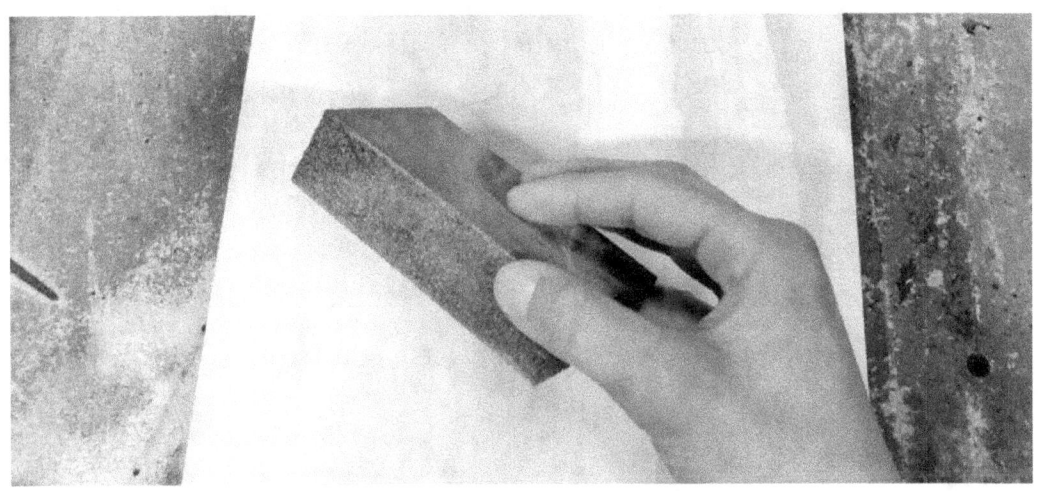

Using a sanding block or power sander, sand both sides and all edges of the wood.

Ensure that the surface is smooth and free of price stamps, gouges, and rough patches.

Step 3: Apply Polyurethane or Stain

If you plan on staining your wood, follow the directions on the can.

Depending on the type of stain being used, you may need to apply multiple coats and add a polyurethane top coat. If you're unfamiliar with stains, ask about the steps required for different kinds before you purchase one.

Some stains come with a top coat mixed in and require only a single coat, which saves time but also prevents the use of multiple coats especially if a single coat does not yield the desired color.

> **For this project, I wanted the natural wood look so I only used polyurethane.**

When administering the polyurethane or stain, take care to apply it evenly and smooth out any air bubbles. Use a soft foam brush to avoid brush strokes.

After applying the polyurethane, set the wood aside to dry.

Depending on the climate in your area and the type of polyurethane or stain used, dry times range from 5 to 6 hours to 24 hours or more.

If the weather is rainy or humid, allow one full day for the stain to dry before moving on. Even in warm, dry weather, if time allows, it's best to wait at least 12 hours before sanding.

Step 4: Sand the Wood Again

Once the polyurethane is dry, use a fine grit sanding block to lightly sand the surface.

Remember, lower numbers indicated on the sandpaper mean greater coarseness. Opt for a sanding block with a coarseness of 280-360.

When finished, wipe the wood with a soft cloth to remove sawdust.

Step 5: Apply a Second Coat

Apply a second coat of polyurethane, taking care to avoid brush strokes and to smooth out any air bubbles.

Set the wood aside to dry for another 12 to 24 hours.

Step 6: Lightly Sand

Using the same sanding block you used in step four (or even finer sandpaper), lightly sand the surface of your wood one more time.

The goal here is to remove the top layer of luster for a more natural look, not to sand down the polyurethane layer you just applied.

Step 7: Mark the Wood for the Nail Placement

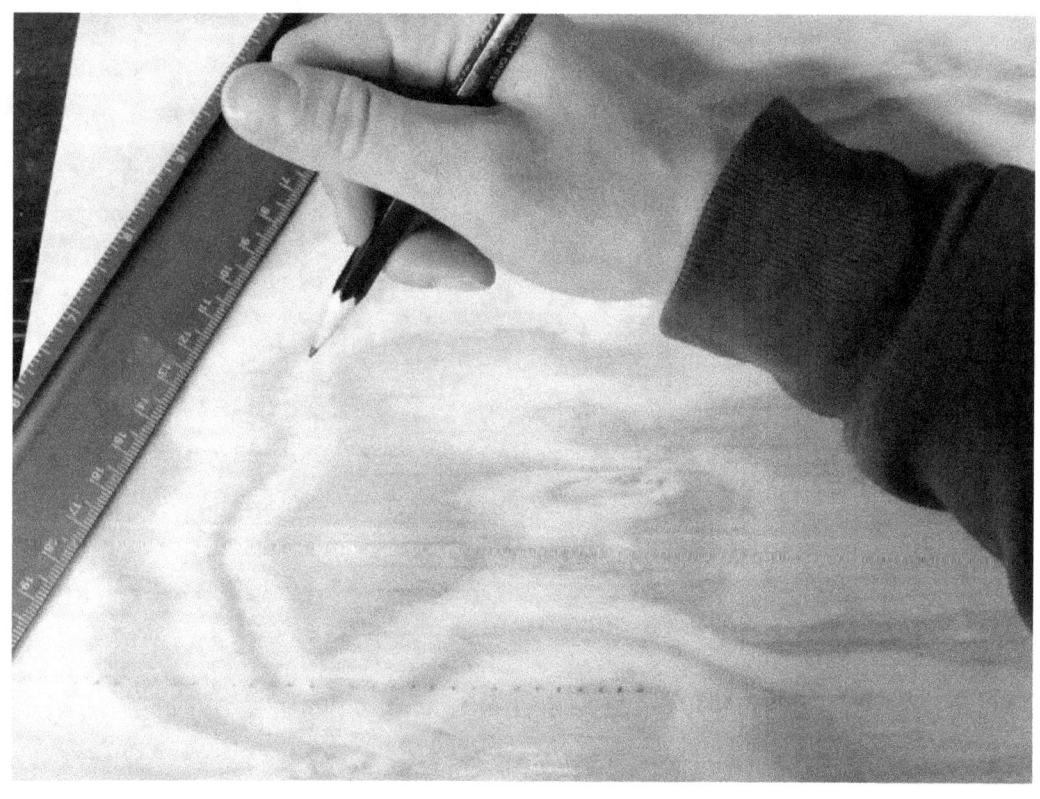

Using a pencil or construction chalk, mark the wood for nails by dotting the outline of the picture you want to create.

 Each dot represents where a nail will go, be as creative as you want!

Space dots between one-centimeter and one-inch apart in length.

For this step, you can use a printed image, a stencil, map, magazine cutout, or you can draw the image by hand.

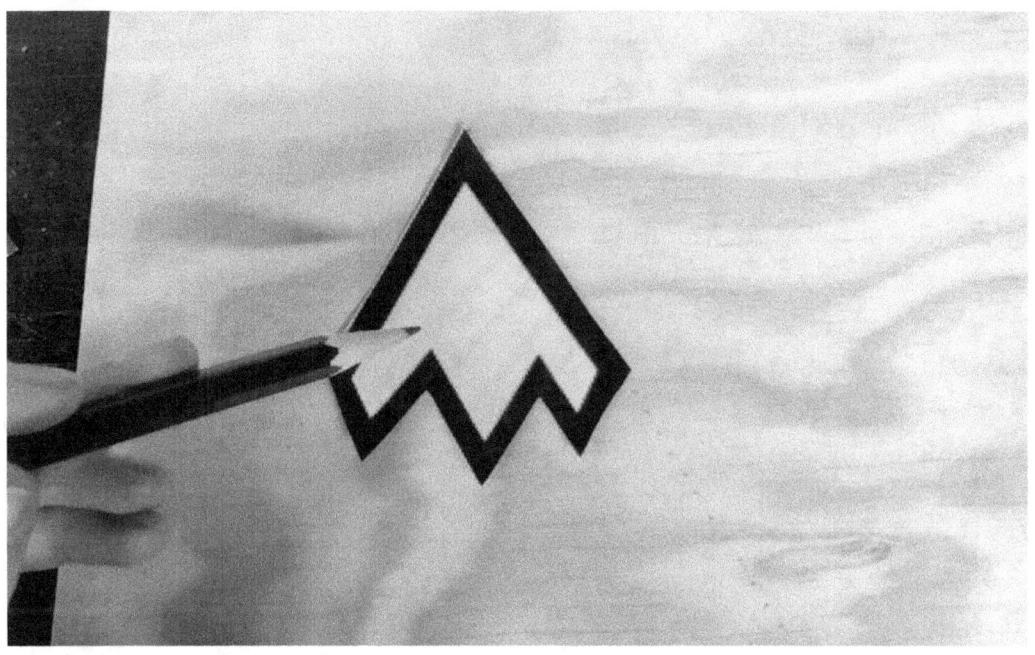

Remember, the more complicated or intricate the picture, the more difficult it will be to make.

I opted to do icon-like mountains and used a ruler for their base. I used printed graphics for the snow caps on top.

Step 8: Hammer the nails

Hammer a nail into each dot. Nails should be hammered half-way to three-fourths of the way through the wood, but should not breach the back surface.

You should leave about a half-inch to an inch of each nail exposed on the front.

 Placing the nails is the hardest part of this project!

Each nail should be at a 90-degree angle from the surface of the wood.

The top of its head should be level with all the other nails.

You can inquire about obtaining a guide at the hardware store or make one from a small durable object you have laying around your house.

Place the guide against the body of the nail before you begin to hammer it.

When the head of the nail reaches the top of the guide, stop hammering. Repeat with each nail and all nails will be the same height.

Step 9: Review Nail Placement; Prep the Yarn

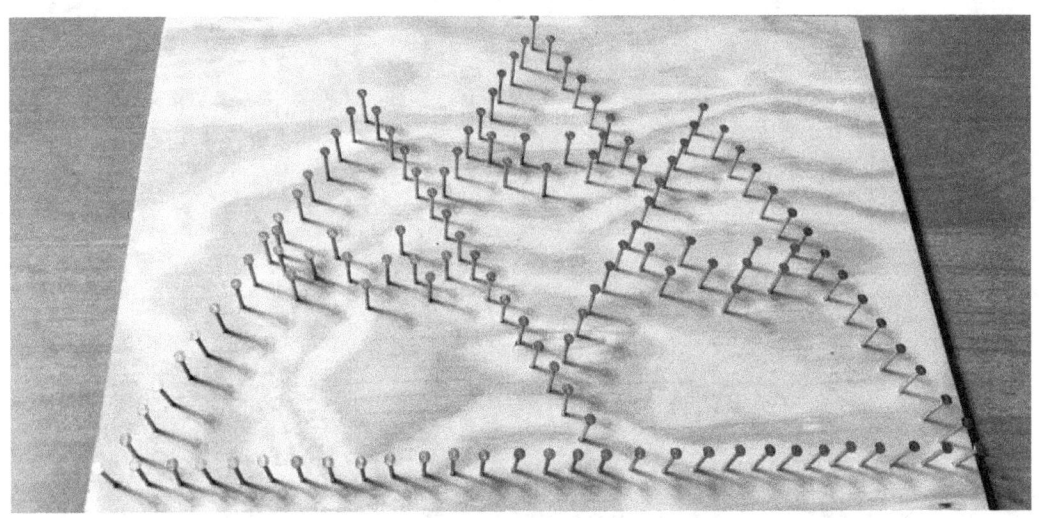

Once all of the nails are in place, take a step back to review the image.

If your image is simple, like these mountain pictures or any basic outline, it should only take a few seconds to review.

However, the more complicated your image, the more closely you need to examine it.

If, for example, you are doing a picture of an owl and want to alternate colors between tufts of feathers on its belly, note where each tuft begins and ends.

The order of your yarn should be added to each part to achieve your desired look.

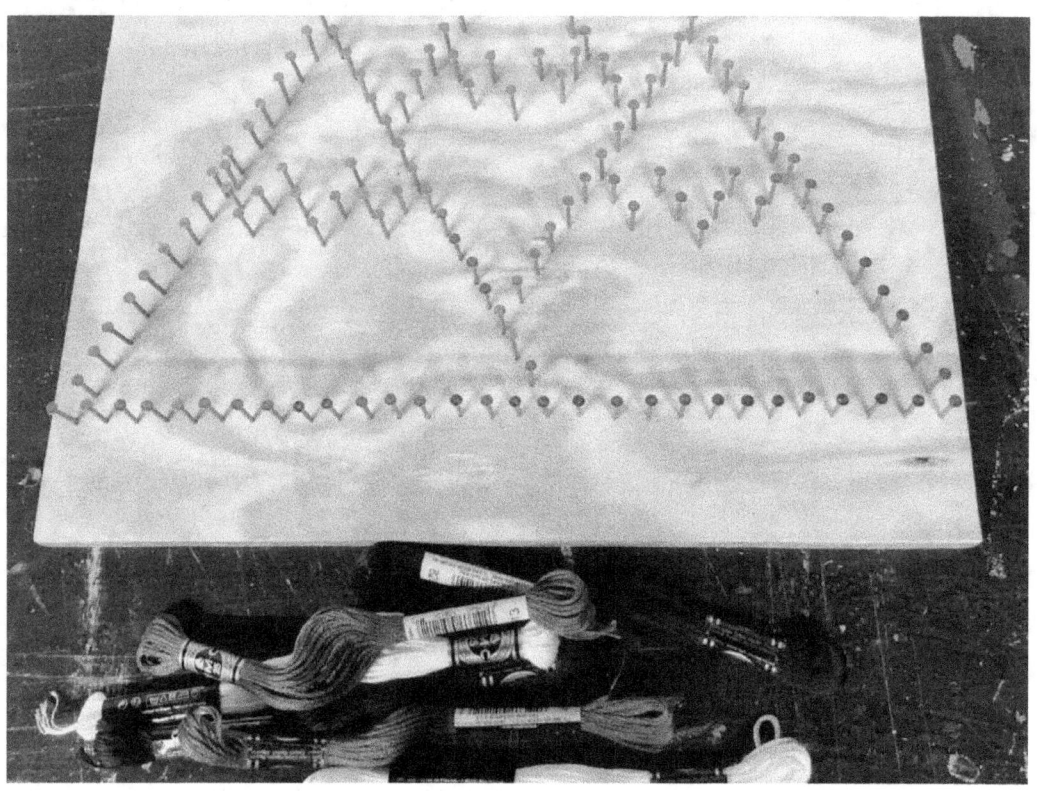

Bear in mind that the thread in the first section you complete will lay below the thread in any overlapping sections.

If you realize you covered a background section, which should have been threaded first, after adding the thread to a foreground section you have two options for fixing this.

First, you can remove the thread and start again. Alternatively, you can thread the background section underneath the already woven foreground section.

 The latter is possible, but it's more difficult and takes longer.

Once you're confident in the location and order of the threading of each item in your picture, prep your embroidery thread.

Step 10: Tie Embroidery Yarn on First Nail

Starting with a nail bordering the background part of your image, attach the embroidery yarn to the nail with a double knot. Trim off any excess yarn remaining on the short side of the knot. If your outline doesn't have a foreground and background, tie embroidery yarn to any nail.

Step 11: Outline the Object

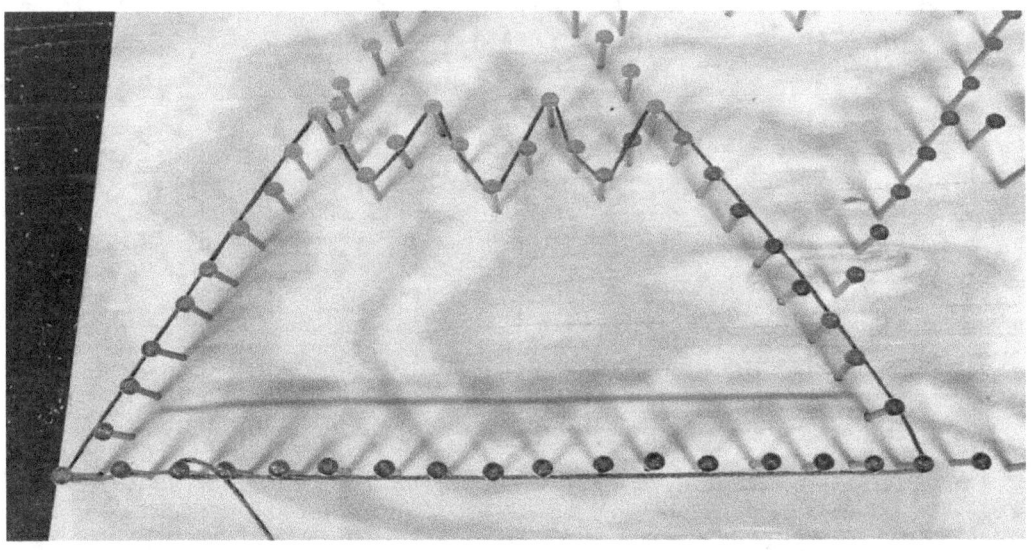

Run yarn along the outer edges of the nails outlining the object or shape.

Once the yarn is looped all the way back around to the first nail, wrap it around the nail once, pulling as you do to make sure the yarn border is taught.

Repeat. Wrap the yarn around the nail once more, pulling tight to ensure the border is secure.

Step 12: Weave Yarn Across the Nails

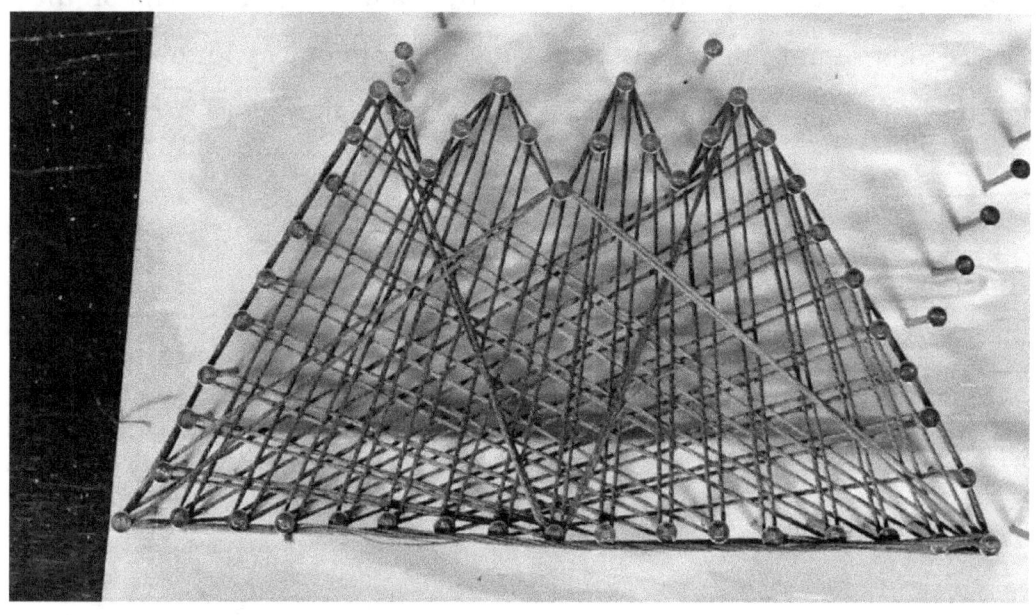

Cutting across the object, loop yarn around a nail on the opposite side of the shape. Weave yarn around the nails opposite each other that border the object. Each time you weave, cut across the center of the object. You can weave the yarn around the nails in any pattern you like.

It may be helpful to play around with different patterns first.

Once you've settled on one and the interior of the shape is filled with crisscrossing strands, lightly pull on the yarn to ensure it is taught. Tie it to a nail with a double knot.

Step 13: Repeat Steps 10-12

If your image is a single shape, take a step back to ensure you're pleased with the design. Take a moment to consider if you need to make any changes at this point.

If your image has multiple objects or foreground and background, repeat steps 10-12 with each object. Start from the furthest back in the image to the front most section of the foreground. Repeat until each object has been threaded and your picture is complete.

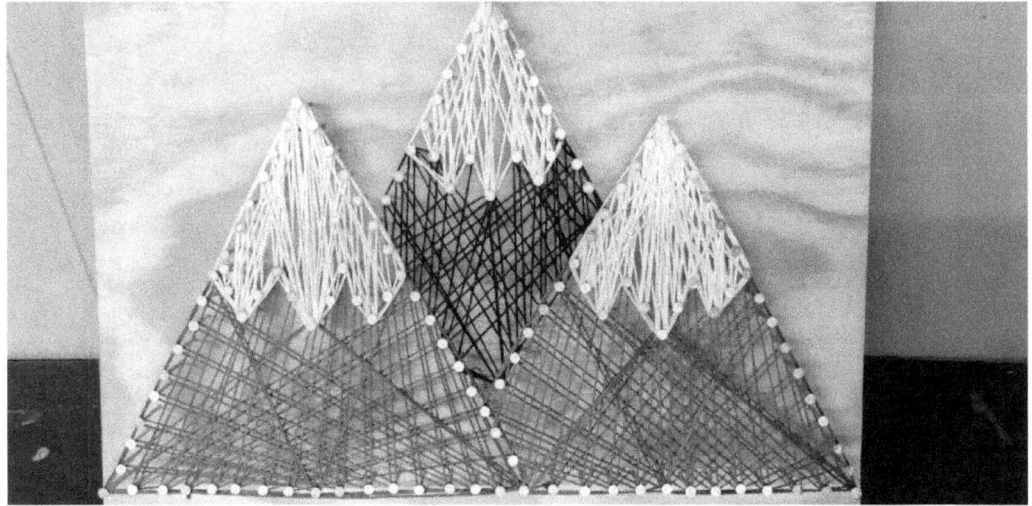

Wood Photo Transfer

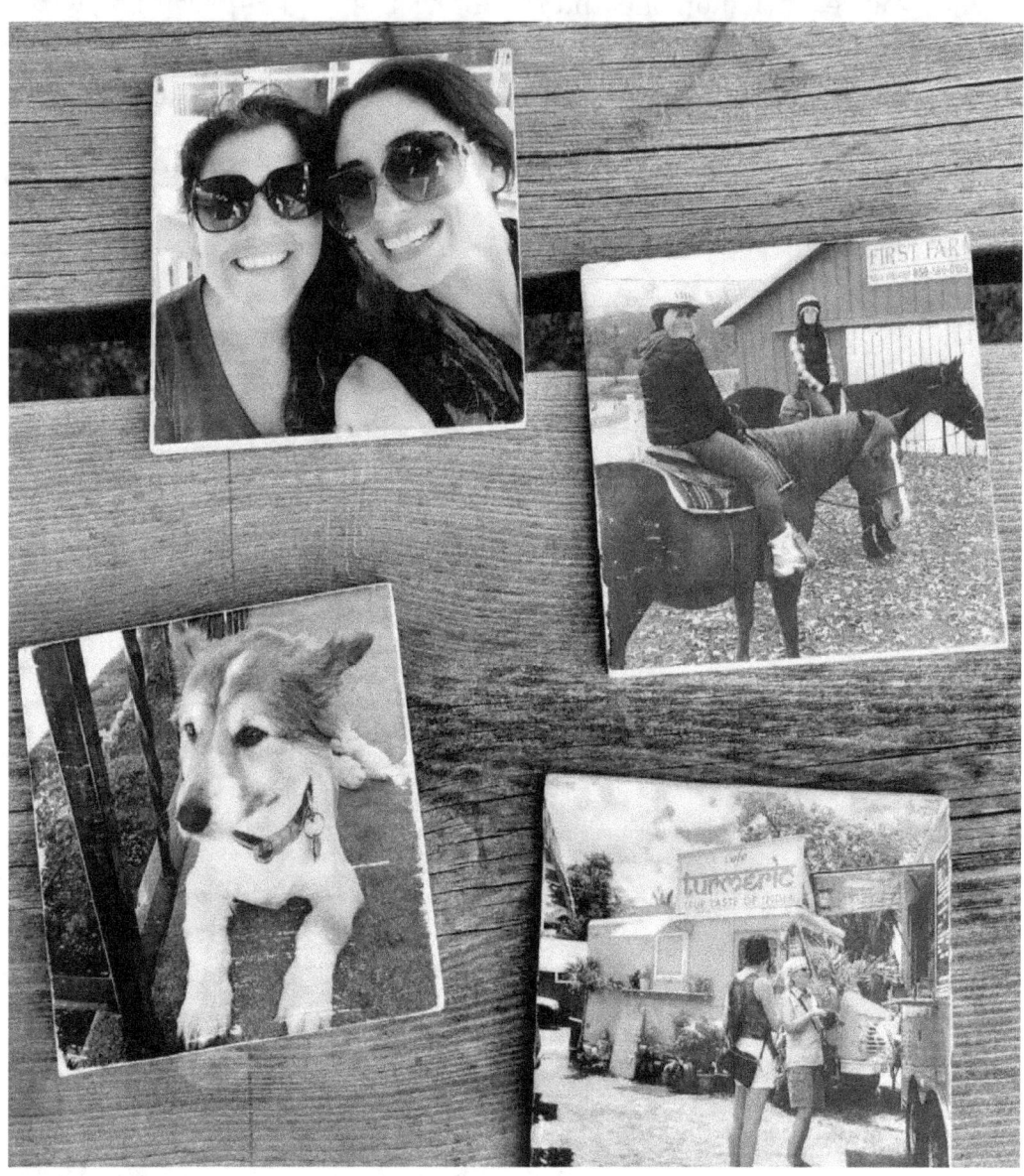

Skill Level: Advanced

This project isn't difficult, but it does require multiple days, careful refinement and much patience. Because of the patience and precision required, this project is best for adults to tackle.

Supplies

- Unfinished Wood

- Laser Printed Photograph on Standard Copy Paper

- Photo Transfer Gel

- Foam Brush

- Fine Grit Sanding Block

- Polyurethane

- Clean Rag

- Small Container (for water)

- Disposable Container (for photo transfer gel)

Preparation

Prepare both an indoor and outdoor workspace.

Your indoor workspace doesn't have to be covered, but covering your indoor work surface with an old rag or paper towel makes clean-up a lot easier. The outdoor work area will be used for cutting, sanding, and applying polyurethane.

Steps

Be prepared for this entire process to take several days to complete.

Step 1: Obtain Laser-Printed Copies

Get a laser-printed copy of the picture you want to use for this project on standard copy paper. Most home printers are ink-jet and can't be transferred the way we will transfer this picture.

Copy stores and shipping stores, like FedEx and UPS, use laser copiers. A copy of a photograph or a picture printed from home only takes a few seconds and usually costs less than $1.

 If you're using a photograph, opt for one without writing on it.

If you're printing a picture from home, inverse the image before printing it. If it includes words or figures when you print it, the words appear backward.

Step 2: Cut the Photo Copy

Using scissors or a precision craft cutter, remove the white border around your photocopy and cut it to size. When finished set it aside.

Step 3: Cut the Wood

Once you have selected your wood, cut it down to the correct size using a circular saw.

If you're unfamiliar with power tools and unable to find a piece of wood in the size you need, your local hardware store may be able to assist with cutting your wood.

Chain hardware stores also rent tools.

If you don't have experience using a power saw, play it safe and ask for instructions before you bring it home.

For this project, I used leftover wood from another project and trimmed it down to about seven-and-a-half inches by nine inches.

The sample image at the start of the chapter is made with balsa wood cut 4" by 4" and will be used as coasters.

The wood's original size isn't much of an issue for this project.

It was originally about seven-and-a-half inches wide and I cut it to a length of 10 inches.

Step 4: Sand the Wood

Using a sanding block or power sander, sand both sides and all edges of the wood so that the surface is smooth and free of stamps, gouges, and protrusions.

Then, wipe the wood with a soft cloth to remove sawdust.

Step 5: Apply Photo Transfer Gel

Make sure to wipe away all the sawdust. Transfer the wood to your indoor work area.

For this step, you'll need the photo transfer gel medium, a disposable container, two foam brushes, and your laser-printed photocopy.

First, pour some of the photo transfer gel media into the small disposable container. Use a foam brush to apply an even layer of the gel to the surface of your wood.

 The goal here is moderation.

The gel medium layer shouldn't be so thin that it appears completely translucent or begins drying on one end before you get to the other end. You don't want it too thick either.

Step 6: Place the Photo Copy

With the image side facing downward, carefully place your laser-printed photocopy onto the gel medium coated surface of the wood.

 Go slow here to reduce air bubbles.

You want the photocopy to lay completely flat against the wood. Air bubbles, creases, bends, and wrinkles will affect the quality of the transfer.

For small images, loosely clasp the top and bottom edge between your thumb and forefinger. Lay down the middle of the image first, then

release the edges and slowly smoothe the image from the center outward.

This method works great for smaller transfers, but not so much for larger ones.

For larger transfers, work your way out from the center to each of the four corners. Slowly smooth out air bubbles. Lift and re-lay in place to remove creases.

As long as there are no large air bubbles or folds, you can try to even out minor defects using a rolling pin, squeegee, or a plastic ruler.

Remove any excess photo transfer gel medium that may have squished out in the smoothing process.

Use the second foam brush and wipe around the edges of the photocopy and the sides of the wood.

Then, set the wood aside for 24 to 48 hours and let the gel medium work its magic.

Step 7: Use a Wet Rag

We're getting to the part that takes a while, makes a mess, requires patience, and needs a gentle touch.

 It's not ideal to start this step if you've only got a couple of hours or your mind is not able to concentrate on the task at hand.

Allow the project to sit another day if you don't have the time and patience to dedicate to it now. Letting it set won't affect the outcome of the photo transfer, but rushing the next steps might.

After you've allowed your photo transfer project to sit for at least a day, prep a small container of water and refresh your work area.

You may want to cover your workspace with a clean cotton rag or paper towel.

Run a clean cotton rag under lukewarm water until it is thoroughly drenched.

The rag should be disposable and slightly larger in size than your wood.

Lightly ring it out so that is soaking wet, but not dripping.

Step 8: Wet Blanket

Place the rag on the back of the wood and spread it out so that entire photocopy is covered by the wet rag. Allow it to sit for 10 to 12 minutes.

Step 9: Rub

Remove the rag. You should now be able to faintly see your image.

Wet your index and middle fingers in the container of water. Gently move them in a small circular motion in the corner of the photocopy.

As you do this, the paper will begin to come up. Take care to move slowly and gently in order to avoid bringing up the transferred image below the paper.

Often during this process, you will have to get your fingers wet.

Step 10: Peel

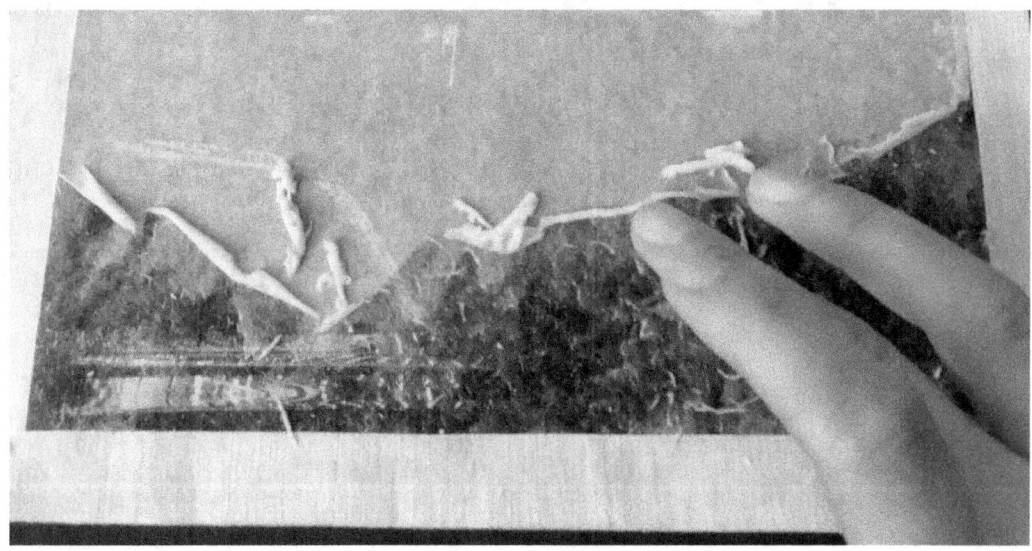

After you've removed the bottom inch or so of paper, re-wet your finger and place it on the exposed section of the photo at either end. Lightly push upward on the edge of the paper.

Once it begins to roll up, move your finger about a half an inch over and repeat, re-wetting as necessary.

Do this until the entire bottom edge of the paper is curling upward. Very gently work your way back across peeling and rolling upward about an inch.

 Re-wet your fingers as needed throughout this entire process.

When you've reached the other side of the photo, work your way back across the photo peeling and rolling upward about an inch at a time.

Repeat until the entire back layer of paper is removed.

Step 11: Allow the Wood to Dry

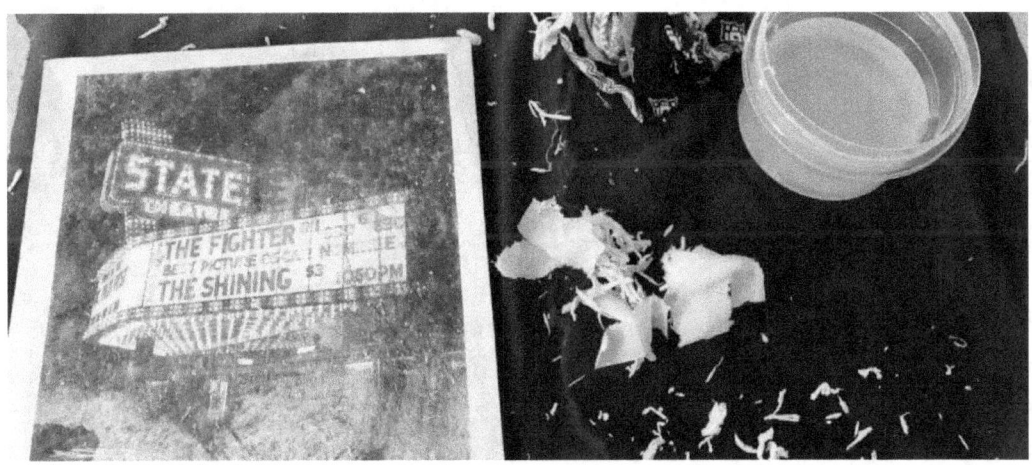

As the image begins to dry, a semi-transparent white covering will begin to reappear.

When you are finished with Step 10, set your wood aside and allow it to dry.

You will know it is dried completely when the semi-transparent white layer covers your entire image.

Step 12: Round 2 Rub

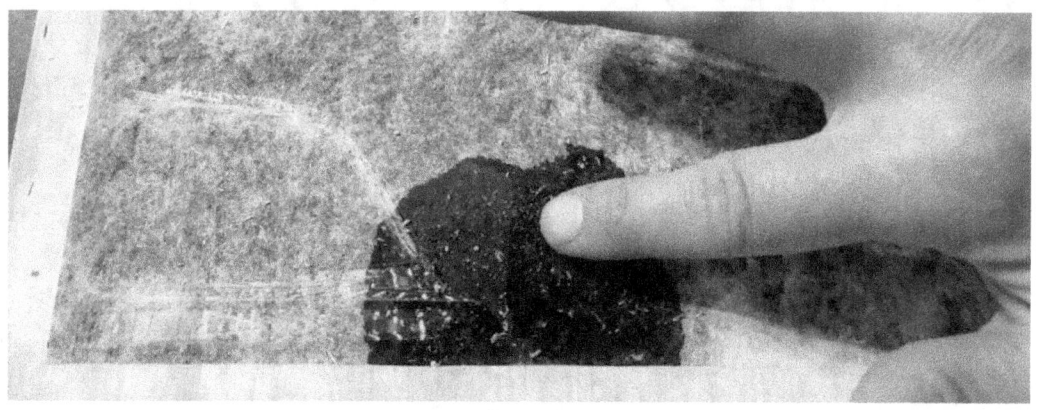

Using moistened fingers, gently rub away at the second layer of the photocopy paper in small circular motions.

 This is where the process gets messy – as if it weren't already!

The remaining layers of paper are too thin to roll and peel upward. Gently rub them loose.

Lightly brush them away with your other hand or a dry foam brush.

Take care while you do this as not to rub too long in a single spot or rub anywhere too vigorously.

You risk rubbing through the image below the paper layers.

Depending on the size of your photo, this step of removing the paper may take several hours.

If you're unable to complete step 12 in one sitting, that's okay. If you need to, you can set it aside for a few hours, or a day, to complete at a later time.

Step 13: Round 3 Rub

After completing Step 12, again allow the wood to dry.

When it dries this time, your photo should be much more visible. Instead of appearing as though it has a layer of white over it, it should look like it's covered in a thin, fuzzy film with a white tint.

Repeat Step 12. So so even more carefully and slowly as it is now easier than ever to accidentally rub away parts of your photo.

 Remember to continually re-wet your fingers throughout this process.

Once you've removed the final film of paper left, set your wood aside to dry.

Alternatively, if you prefer the look of wood-exposing tears in the image, you can use a little more force, but still, be careful not to lift too much of the image as you do this.

Step 14: Spot Rob

Once the wood is completely dry, check the image for areas with remaining remnants of paper.

Areas, where paper remnants remain, will appear as though they are covered in a thin layer of white-transparent moss. There should not be too many at this point. If some remain, wet your fingers and very carefully massage them away.

 The image may look cloudy or foggy, but the polyurethane top coat in Step 15 will return the picture to its original vibrancy.

When you're finished, use a high-density, super soft foam brush to gently brush away any remaining paper remnants. Set the wood aside to dry.

Step 15: Apply a Top Coat

When the surface of your wood is dry and wiped free of any paper remnants or other debris, use a high-density foam brush to apply a top coat.

For this project, I opted for Polyurethane because it goes on smoothly and clear. It will seal the wood well.

As you apply the polyurethane be careful to avoid stroke lines and watch for air bubbles. Smooth out all air bubbles before setting wood aside to dry.

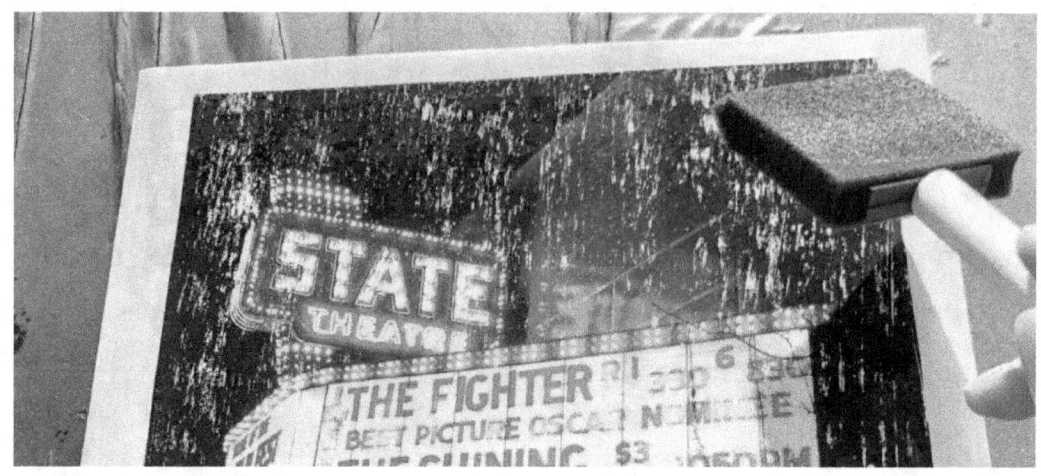

Dry times will vary based on the type of polyurethane used and the local climate. If your can doesn't say "quick drying" and the weather is even moderately humid, allow at least 24 hours to dry. Even if you're using a quick-drying polyurethane in a drier climate, for best results, allow a minimum of 10 to 12 hours to dry.

Step 16: Buff

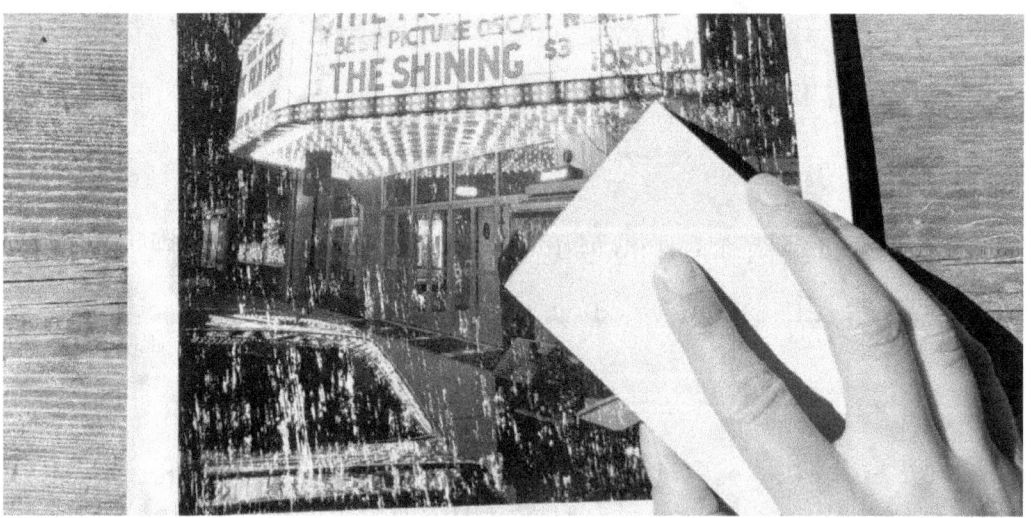

Once the polyurethane coat is completely dry, use a very fine grit sanding block, with a grift of 220 to 320, to light buff the base coat.

Step 17: Second Coat

Using a soft clean rag, wipe the surface of your photo transfer. Make sure it's free of debris.

Apply a second thin coat of polyurethane using a high-density foam brush. Again, take care to avoid brush lines and air bubbles. Allow 12 to 24 hours to dry.

Step 18: Light Buff

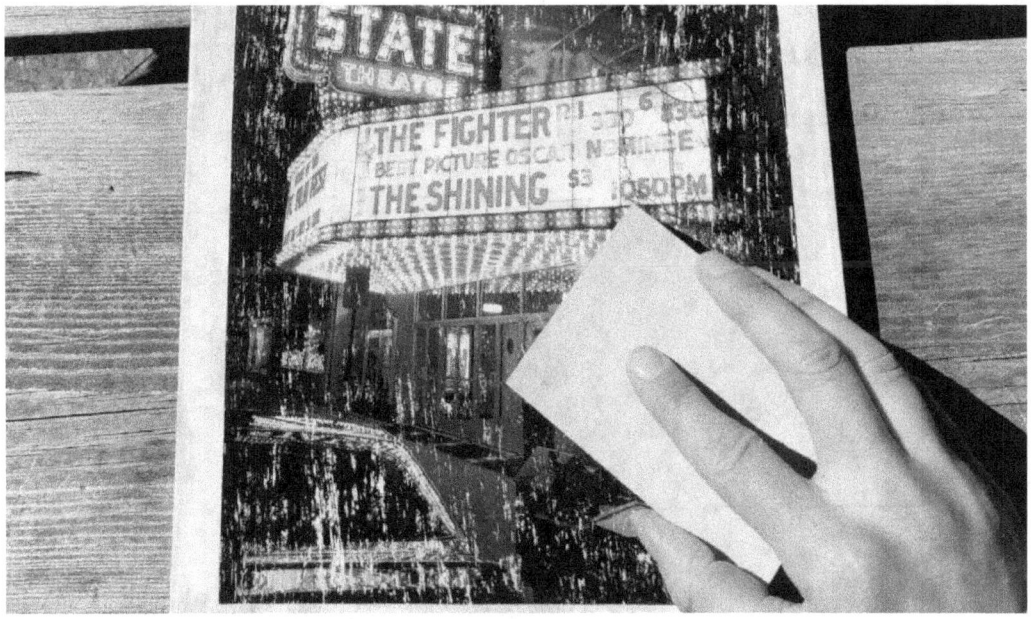

Using the very fine grit sanding block used in Step 16, lightly buff the surface of your photo transfer to reduce the sheen of the polyurethane. Wipe it with a soft, clean rag.

Step 19: Enjoy!

Conclusion

I hope you now have a better appreciation for your own artistic ability. Anyone can create beautiful works of art!

You can try these 10 projects on your own time but practice makes perfect. As you complete these items more than once, you will find little things you can tweak or do differently next time you make them.

Imagine creating artwork as presents for your friends and family. These projects make great gifts for birthdays, graduations, weddings, house warming parties, hostess gifts, and anniversaries. You can customize any of these projects to fit the occasion and the recipient.

If I have inspired you, as I hope I have, would you please consider leaving a review wherever you purchased this book? I sincerely value your feedback.

I hope to write more art books, so be on the lookout for successive volumes filled with even more easy, colorful, interesting art projects.

Thank you so much for reading this book and have fun making some art from your heart!

www.ingramcontent.com/pod-product-compliance
Lightning Source LLC
Chambersburg PA
CBHW081432220526
45466CB00008B/2352